TOGETHER

POTLUCK

BUILD

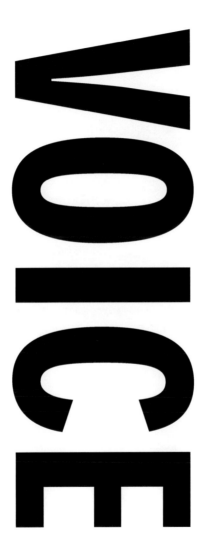

HAMMER

HULA HOOP

PLEIN AIR

Tools of the Commons
The highlighted words featured throughout this book represent some of the many "tools" Open Field employs in the making of a commons. Randomly listed, they illustrate the divergent and unconventional apparatus of the endeavor as a whole.

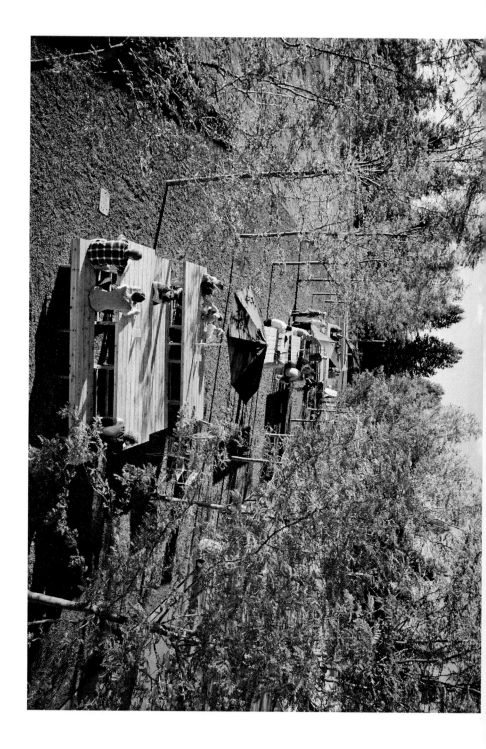

Custom-built picnic tables accommodate friends and strangers on the Walker Art Center's tree-lined plaza, 2010

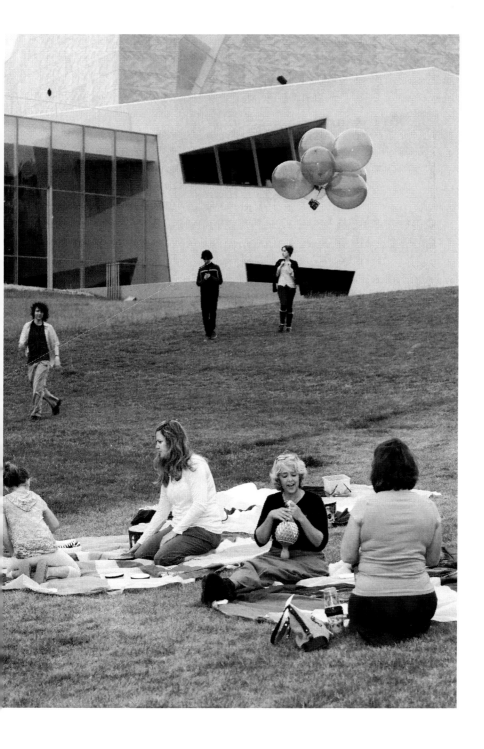

An aerial balloon camera designed by D.E.M.O. shares the field with a Kindermusik activity at Free First Saturday, 2010

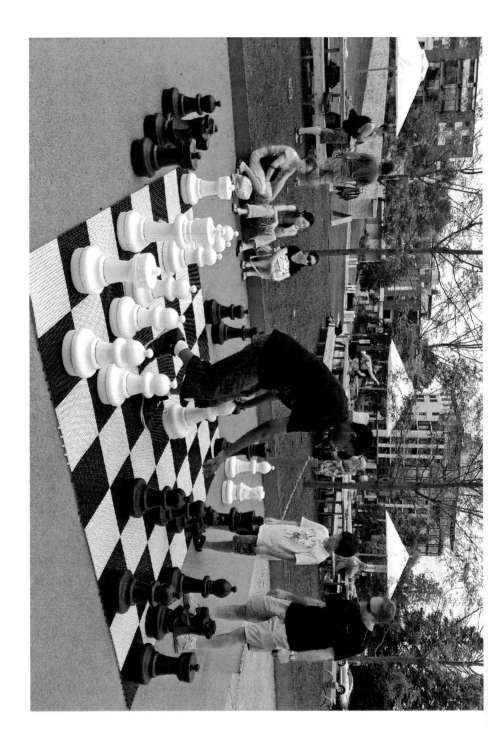

In a game of human chess, players might be captured by a live queen or toss a pawn into the wild green yonder, 2010

Open Field: Conversations on the Commons

Edited by Sarah Schultz and Sarah Peters

Contributions by Susannah Bielak, Steve Dietz, Stephen Duncombe, Futurefarmers (Amy Franceschini, Michael Swaine), Lewis Hyde, Jon Ippolito, Marc Bamuthi Joseph, Machine Project (Mark Allen), Sarah Peters, Rick Prelinger, Red76 (Courtney Dailey, Dylan Gauthier, Sam Gould, Gabriel Mindel Saloman, Mike Wolf), Sarah Schultz, Scott Stulen, Works Progress (Colin Kloecker, Shanai Matteson)

Walker Art Center, Minneapolis

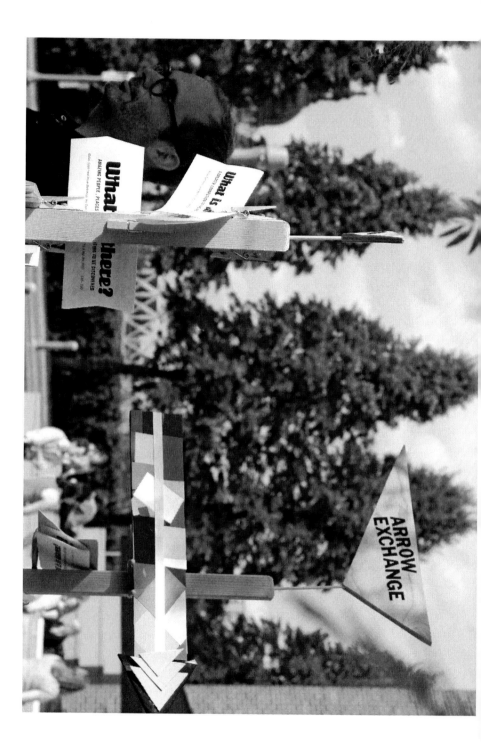

Minneapolis artist Mike Haeg's Arrow Workshop & Exchange helped bridge the distance between people and destinations, 2011

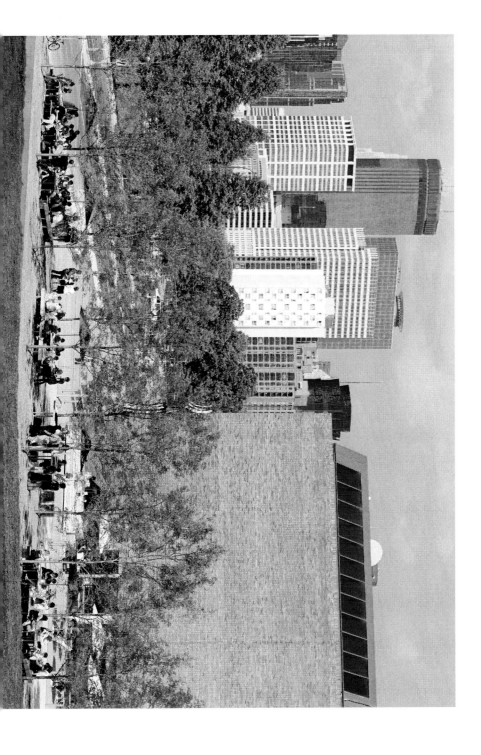

Minneapolis skyline and the Walker's tree-lined plaza as seen from
Open Field, 2010

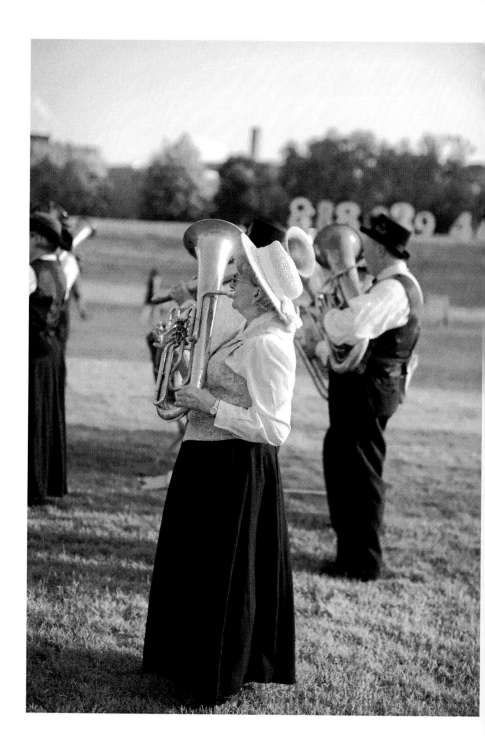

Introduction

"What does it mean to be creative as conscious social activity—to create a commons, rather than individualizing creativity?" —Joshua McPhee

Open Field is a three-year, summerlong project of the Walker Art Center that adopts the commons as a philosophical and programmatic framework to imagine a new kind of public gathering space. Grounded in the belief that creative agency is a requirement for sustaining a vital public and civic sphere, it nurtures the free exchange of ideas, experimentation, and serendipitous interactions. Whether hosting a collective of artists building a schoolhouse, a pickling demonstration, or a raucous group of children

rolling down a hill, Open Field attempts to break with a number of timeworn conventions about the role of museums, creativity, and public life. Specifically, the project challenges the notion of the museum as the primary author of artistic content and cultural experience. It also resists the idea that creativity is an individual pursuit belonging primarily to the artist and operating outside the realm of everyday life.

Taking place on the four-acre lawn adjacent to the Walker, it began with the seemingly simple question, "What would you do on an open field?" Over time, as the physical space of the field was inhabited and claimed by various constituents, it acquired a distinctive sense of *place* through acts of negotiation, interaction, and exchange, bringing meaning to its tagline: "Open Field is what we make together."

In the spirit of inclusivity, Open Field invites everyone and anyone to bring their best creative self forward as producer or participant. Indeed, a key aspect of the project—one that places it both literally and figuratively outside the Walker's institutional walls—is the invitation to the public to share their own creative interests with minimal mediation and modest support from the museum. These activities occurred alongside a series of curated residences by artists—mostly collectives—whose work pointedly addresses participation in the public sphere. Those events, in addition to the Walker's educational programs and new social amenities such as picnic tables, food service, and a Tool Shed, evolved together to make Open Field what it is—an eclectic mash-up of activities and people.

People gather on the lawn for Open Exposure, a music festival organized by the Walker Art Center Teen Arts Council, 2010

What do we mean by "the commons?" Generally speaking, a commons is a resource shared by a group of people and a process by which the goods (materials or intellectual) are held and managed collectively. Why build a project around this idea? The commons as a concept was seductive because it is both suggestive and vague enough to embrace a plurality of activities, definitions, and outcomes that could lead to new practices and behaviors. For example, if we explored the definition of the commons as a shared resource, would the Walker understand its assets differently? How might we afford access to things such as our public and private spaces, collections, knowledge, staff time, or social and cultural capital? If we think of the commons as co-creation, how would our practices of collaboration differ, and with whom would we work? If a focus on the vernacular side of "common" encourages us to think about the museum as an everyday place, what should happen there? At the risk of sounding idealistic, Open Field is about building a more responsive and responsible museum that intentionally sets out to produce something of collective value *with* the public, rather than *for* them.

The interviews and essays in this book account for two years of projects, activities, and conversations that provide a snapshot of Open Field through the particular experiences of the artists and thinkers who participated. This publication was conceived of as a way to wrestle with the implications of the commons as a framework for rethinking artistic and institutional practice. The themes that

emerged include teaching and learning as a collective endeavor; the value of utopian thinking to imagine a different world; how communities form around a place; the importance of embracing risk, failure, and speculation in public practice; and many ideas for ways that museums might transform themselves into shared places of production. Above all, the voices in this book speak to the human desire to make things together, rather than to create culture strictly as individuals.

What this catalogue does not fully account for are the experiences of members of the public who hosted programs or simply showed up to enjoy the offerings on a hot summer evening. A small fraction of the programs organized by visitors are illustrated in the images that populate this book, and a full listing appears in the final pages. One of the challenges of this process is documentation. As most artists are well aware, capturing images of ephemeral work is as important as creating it in the first place—so as the twenty-first-century saying goes, "If there isn't a picture, it didn't happen." A great number of events were photographed by field staff and the public programmers who generated them, but others merely happened, relying on the alternative axiom, "You had to be there."

Our essays in this publication, "My Common Education: Lessons from Open Field" and "When Bad Things Don't Happen," relay some anecdotes from the public contributions to the field, but this is not a full account of every game, conversation, or pop-up concert that happened on the lawn. Our

effort to make sense of our own institutional practices took precedence over creating a full report of the project's first two summers.

Open Field is the sum of its thousands of participants. It evolved from numerous formal and informal conversations between staff and local colleagues, including two community charettes with professionals from the fields of design, art, architecture, and cultural programming. We would like to acknowledge a group of people who devoted a tremendous amount of time, energy, and sweat to make the project happen. The Education and Community Programs staff includes Scott Stulen, Ashley Duffalo, Christina Alderman, Susannah Bielak, Abigail Anderson, and Courtney Gerber; two exceptional field coordinators, Sara Shaylie and Scott Artley; Drawing Club organizers Jehra Patrick, Marria Thompson, Katie Hill, and Kristina Mooney; and a dedicated cadre of interns: Juana Berrio Lesmes, Laura Robards Gantenbein, Nicole Mills-Novoa, Chloe Nelson, Kristina Lovass, Oakley Tapola, Nida Pellizzer, and Andrew Gramm. The project benefited greatly from the thinking of Steve Dietz, director of Northern Lights.mn, and Colin Kloecker and Shanai Matteson from Works Progress. It would have been impossible without the outstanding problem-solving and tactical insight of Walker colleagues Andrew Blauvelt, Robin Dowden, Ryan French, Ben Geffen, Cameron Zebrun, David Dick, Carolyn Dunne, Phillip Bahar, and Dean Otto. We owe much to John Lindell, Joey Heinen, Emma Rotilie, Jay Luniewski, Tony Dockendorf, Todd Gregory, and everyone in our security, visitor services,

and operations staffs, who were on the ground and in the public with us every day. Mary Polta and Annie Schmidt helped make Open Field financially viable. Designers Andrea Hyde and Dante Carlos gave the project a distinctive feel, while Justin Heideman and Tyler Stephanich developed our user-friendly website. Adrienne Wiseman, Rachel Joyce, Kristina Fong, and Julie Caniglia worked tirelessly to communicate the project's many parts to the public.

Thank you to Pamela Johnson and Kathleen McLean for their sharp eyes in editing this book. Thanks to Walker photographers Cameron Wittig and Gene Pittman for many of the images that fill these pages. Kudos to Alex DeArmond for his elegant design, and to Emmet Byrne, Dylan Cole, and Greg Beckel in the Walker Design Studio for steering a complex publication through to completion.

Open Field was sponsored by Target in summer 2010 and Optum in summers 2011 and 2012. We would like to acknowledge Walker trustees Shawn Gensch (Vice President, Brand Marketing, Target) and Dawn Owens (CEO, OptumHealth) for their advocacy and enthusiasm for this project.

Finally, we would like to thank Walker executive director Olga Viso and honorary trustee Angus Wurtele and his wife, Margaret, for their unwavering faith in and support for this experiment that has taken place in the museum's backyard.

Sarah Schultz and Sarah Peters

RISK

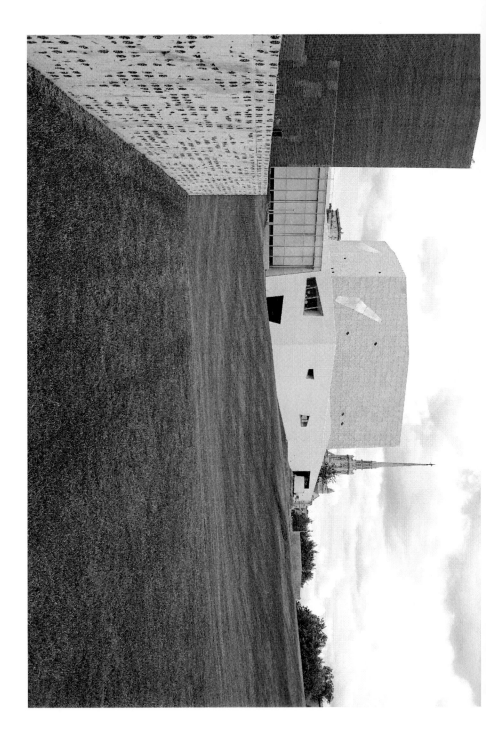

We began with the question "What would you do on an open field?"

My Common Education: Lessons from Open Field

Sarah Schultz

"The common willing of a common world is an eminently practical undertaking and not in the least abstract."[1]

It's a muggy July night and hundreds of people are milling outside the museum. A crowd is gathered under a tent to watch local chefs make sauerkraut. A group of regulars has grabbed some beers and joined the Drawing Club. Yarn bombers known as the Swatch Team are stationed at a nearby table, inviting anyone to knit. Far off in the field, an artist in a prairie bonnet sings to grazing sheep. The animals are followed with a boom mike to capture the soft sounds of chewing grass. The lawn has not been cut for weeks in anticipation of the evening's grand finale — a

1. Daniel Kemmis, *Community and the Politics of Place* (Norman, OK: University of Oklahoma Press, 1990), 122.

concert of people mowing the field in tandem. A line has formed as the composer ties bells to the reel mowers volunteers have brought from home. He explains how they will move in three different groups around the seated audience. After twenty-six minutes, each individual will choose a path and mow off the hill out into the neighborhood. We overhear a woman saying, "This is a really exciting experience. I never imagined that I would be performing at the Walker. I can't wait to tell my friends."

The Walker Art Center campus includes four acres of largely open greenspace directly adjacent to the building. Situated on the edge of a residential neighborhood, it is flanked by a large downtown park and the idyllic Minneapolis Sculpture Garden on two sides and a busy freeway entrance on another. This parklike space is open to all, but privately owned, similar to many other public urban environments. Originally intended for development as part of the Walker's 2005 expansion, the landscape design of the field, along with a proposed plaza entrance, was postponed. A notable addition was James Turrell's *Sky Pesher, 2005* nestled into the top of the hill, a room-size chamber whose ceiling opens up to the sky. Over the years, museum staff episodically used the field for large outdoor concerts, a mini-golf course, and traditional education activities such as workshops and family days. However, as time passed and people began simply to inhabit the field — having picnics, walking dogs, or just rolling down it with their kids — we were left to wonder what might happen if we thought of our open space

Community choreography forms the basis of Chris Kallmyer's *the American lawn and ways to cut it*, 2011

as a shared resource. How might it frame cultural participation as a collective and dynamic process? What form of public park could emerge from the context of a contemporary arts center? There aren't a lot of public places left in our lives where we can comfortably encounter people who, while they may not share our precise interests, hold in common an inclination toward engaged curiosity. In many respects, museums already serve this community, but an empty field provided us a rare opportunity to test something new. As a commons, the field was seen as a place for creative, social, and intellectual exchange and production rather than as a venue for the sort of presentation and cultural consumption typical for gallery, stage, or lecture room.

We assembled a loose group of non-Walker collaborators, and as we struggled to figure out how best to move forward, we jumped at their recommendation to host a community charette, a collective brainstorm session that would generate ideas; such communal planning seemed to us altogether appropriate to the goals of Open Field. This format turned out to be such a fruitful one that we repeated it the following year with a different group of artists and programmers. Six months before the opening in January 2010, thirty designers, artists, and cultural producers sat down together to think through the field's unique physical challenges as well as the conceptual and logistical dilemmas of how to engage people both creatively and socially. By the end of the day, the group identified the site's most pressing constraints and proposed an imaginative range of

fig. 1

fig. 1: A speculative model illustrates ways that artists and audiences would work together, 2010 Illustration: Sarah Peters

2. For more on the charette process, see Andrew Blauvelt, "Crowdsourcing the Open Field: Setting the Stage for Summer in the Walker's Backyard," *Walker Art Center Design Blog*, http://blogs .walkerart.org/design/2010/03/25/crowdsourcing-the-open-field/.

solutions, including a final plan for a shaded picnic area, along with the addition of a bar and grill and a plaza that could function as an impromptu stage.[2]

The most difficult part of planning Open Field turned out to be the process of unscripting our own expectations and ideas about what should be developed. We knew we wanted the public to participate in programming, and we collectively wrestled with how to imagine an open, experimental, and functional environment that would achieve this. Walker staff had to acknowledge and set aside biases about the types of activities that people should organize; in my case, that meant foregoing some minor anxiety about mimes and juggling and a decided

Charette participants tackle the challenges and possibilities of Open Field's physical infrastructure, 2010

BANNER/EASEL WIND WAVES. HAMMOCK

fig. 2

preference for jam-making and knitting. We were also concerned about the equity or balance of the space — that no one person or group should dominate the field in such a way that made it impossible or unpleasant for others to inhabit it with them. In the end, we took what I believe was an ambitious leap for our institution, making an earnest attempt to create a supported space in which anyone with virtually any idea or creative practice could participate.

"I have a right to know what kind of 'experiment' I'm involved in!" insisted one of our collaborators when we began to explain the project as an open experiment with the community. It was a stark reminder that we were changing the "rules" of institutional business-as-usual for the audience as well as for ourselves. We had some basic questions to address, and we needed to do so with transparency: How is one supposed to participate in a cultural commons? For that matter, what is a cultural commons? Nina Simon has written extensively on the need for "scaffolding" participation, creating the structures by which people understand and are comfortable with how to engage and contribute.[3] Since the museum and the public were literally entering

fig. 2: Tools and amenities proposed by charette participants to make the field more inviting, 2010

3. Nina Simon, *The Participatory Museum* (Museum 2.0: Self-published), 12–13, http://www.participatorymuseum.org/read/.

new terrain together, we were most concerned that methods of engaging on the field be: varied (after all, we weren't sure what was going to actually work); familiar but intriguing enough to inspire creative and social risk; more fun than frustrating; and most of all, able to reinforce the values and integrity of a commons. Over the course of the next few months, with the advice of many of our partners, Walker staff designed Open Field by using what I've dubbed in hindsight as the strategy of "rules, tools, seeding, and meeting."

RULES

The first step toward not only articulating our values, but also facilitating a functionally "open field" took the form of the Rules of the Commons, later known as Field Etiquette, which were posted on the website. The construction and refinement of these operating guidelines brought up numerous tactical and philosophical questions, ranging from liability issues and hate speech to commercial promotion and trash disposal. While we struggled with the inherent tension between rules and radical openness, the crafting and enforcing of this document represented an ideological and pragmatic crucible for the project.[4]

TOOLS

Our charette participants introduced the idea of providing "tools" for the field by designing things that would empower participants to create their own experience of Open Field. These included not only

mock-ups for items such as portable seating, umbrellas, and shade structures, but also a model for ways that local artists might function as a kind of human prompt or "resident provocateur" by posing questions, instigating actions, or improvising the flow of exchange between visitors. Conversations on this topic inspired the production of a wooden structure aptly named the Tool Shed, which served as a hub for visitors. The fully realized construction housed sports equipment such as soccer balls, Frisbees, and hula hoops as well as art supplies, a library of books from several local presses, and even a portable tent kit designed by a local artist. Staff stationed there helped to facilitate and orient visitors, encouraging them to rummage through its shelves and use whatever they found inspiring, free of charge.

SEEDING

"Show, don't tell" is every writer's mantra. We also attempted to follow this maxim, yet at the beginning of Open Field's first summer, it took us some time to realize that simply issuing an invitation for members of the public to "organize a book club, host a meet-up, teach others new skills" in a big outdoor space wasn't providing enough direction; we needed to help people imagine the breadth of possibilities for what they might do on our field. A better strategy involved seeding the Walker's commons with activities throughout the summer months, programming that we hoped might galvanize Open Field's community participants to be imaginative and go public with their own interests and proposed uses for the

The Tool Shed, designed and built by David Dick, contains playful tools for use on the field, 2010

space. We found that many had good ideas, but were tentative about doing things in the context of a contemporary arts center, particularly if they wanted to do something that had nothing to do with art. We needed to show participants what was possible, but also to offer them an invitation and, most importantly, permission to become more actively involved in planning programming themselves.

We invited local artists to use the field to experiment, to try things out. They hosted topical conversations; a playwright held public readings of plays; one local publisher even invited the community to pitch book ideas to him in an earnest but playful speed-dating format. One of our editors brought her daughter's Suzuki violin class to practice on the field on several summer evenings, where they provided an unconventional backdrop for people throwing Frisbees or just hanging out and drawing.

"Seed it and then cede it" was a phrase coined during a second charette in 2011. This suggestion became one of our core operating principles — a good reminder for us to resist the inevitable institutional impulse to program or structure the field too greatly. We aimed to lightly seed the field with interesting programs, and then get out of the way to make room for whatever else might then happen.

MEETING

It was quickly evident that the social possibilities of Open Field were just as attractive, if not more so, than the invitation to create structured programs. Most of our audience is simply eager for a place to

meet other curious and interesting people. In order to ensure that there was always something happening on Thursday nights, when museum admission is free, and to offer a low-threshold way for the public to participate, we launched Drawing Club.[5] A weekly collaborative event, the program created an air of informal sociability around a shared task, where one could simply sit down and join in — it was art-making as a communal, informally collaborative endeavor, open to all comers. Along with events such as Acoustic Campfire (weekly acoustic music sets), artist-in-residence projects, and some intentional coordination of the publicly hosted activities, we were able to create unusual and lively programming mash-ups on the field that fostered an atmosphere of creative improvisation and social serendipity.

RESIDENT ARTISTS ON THE FIELD
As much as Open Field is a space for informal creativity, we also viewed it as a site rich with potential for professional artists interested in experimenting with public practice. As it turned out, our resident artists were critical to activating Open Field. Red76, Futurefarmers, Machine Project, and Marc Bamuthi Joseph were all commissioned in the first two summers to approach the field as a launch point for collective production and investigation; they embraced the public as collaborators in imaginative and wide-ranging activities — from the improvised building of a schoolhouse and the construction of a mobile, multi-person megaphone to performances starring neighborhood dogs or requiring push mowers to the

5. Drawing Club is described more fully by Scott Stulen in his short essay in this book, "Drawn Together: Open Field Drawing Club," 111–115.

WEAVE

making of a community classroom for social change. These highly visible projects proposed new ways to envision making, investigating, taking action, or playing on the field. The socially engaged practices of these artists and the intellectual and creative rigor with which they approached the aesthetic, social, and political implications of commons-based cultural practices were crucial to project's evolution. The resident artists' openness and warmth toward the public and their willingness to allow their work to unfold alongside whatever else was happening on the hill played an important role in what Open Field would eventually become: a porous environment that blurred the lines and leveled the playing field between professional and nonprofessional artists, weekend hobbyists, and creative enthusiasts.

During the first two years of Open Field, more than 200 people from the local community hosted programs ranging from storytelling and dance performances to art-making workshops; they brought to the field vernacular forms that included brass bands and knitting as well as social events such as book clubs and cribbage. However, many projects defied easy categorization, such as Spin with the Whorling Sisters or the Ground Breaking Invent Event. One of my personal favorites among these activities — If You Ignore It, It Will Get Better — offered participants free financial advice while they received a massage. For many, Open Field offered a way to share passions and interests with a larger community, and an opportunity to reconnect with creative energy that some thought they'd left behind. Artist and

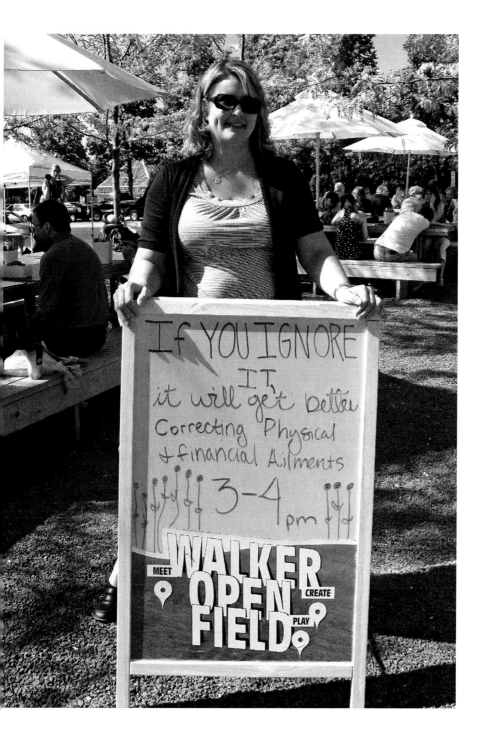

Financial planner Rachel Stulen offered weekly self-improvement workshops, 2011

writer Gregory Sholette has coined the term "dark matter" to describe the array of output by informal artists, amateurs, and other creative producers whose work lies outside the formal art world's critical frames — not by their choice, per se, but because of the "near-virtual hegemony [the elite art world] yields over notions of 'serious' cultural value."[6] Open Field not only brought this dark matter into view, but in some instances fostered it anew by empowering people to see their creative labor as a form of art and themselves as artists. The field functioned not as an arbiter, but rather as a catalyst that generatively and generously supported and made possible a wide spectrum of creative activity.

I heard some say Open Field got the art world out of the way, but of course it didn't really. The contemporary art world was always right there, physically and psychologically adjacent and in constant interplay with everything happening outside in that common space. On Open Field, all forms of social and creative expression were equally respected and validated; the guiding principles of the field and the museum are not in competition, they're complementary — albeit fundamentally different and creating a provocative discursive space where we might hash out questions around cultural value and representation. Indeed, Open Field instigated provocative and soul-searching conversations among Walker staff members around issues of cultural capital and quality, both within and outside the museum. Some worried that we were "diluting our brand" or that people would only come to Open Field and never step inside to the "real"

6. Gregory Sholette, "Heart of Darkness: A Journey into the Dark Matter of the Art World," in *Visual Worlds*, ed. Blake Stimson, John R. Hall, and Lisa T. Becker (London: Routledge, 2005), http://gregorysholette.com/writings/writing_index.html.

museum. Others skeptically suggested that we were trying to get people to do the museum's work for free, a comment that invites one to ask, "What precisely is the work of the museum?"

With the proliferation of alternative cultural outlets and forms, why should it matter that a contemporary arts center undertakes something like Open Field? Quite honestly, it doesn't, if the motive is simply to increase attendance or if the work is done superficially and disingenuously. It's a real challenge for an institution, even with a progressive history such as the Walker's, to facilitate a truly improvised, open environment. It requires a dedicated staff, in attendance and at attention, to participate in and acknowledge the contributions and presence of others as well as patience with failure, faith in serendipity, the courage to relinquish control, and a genuine openness to change. As field coordinator Scott Artley wrote to me after the close of the project's second year, "The physical and intellectual labor of the summer was considerable, but the real *work* was facing and attempting to challenge the institutional practice without alienating the very resources that made it possible to ask the questions in the first place."

"The emergent properties of systems are never apparent from the conditions going in," writes cultural critic Lewis Hyde.[7] The same could be said of my own education on Open Field. What happened on the field was neither scripted nor accidental. Yes, it was scaffolded and seeded to encourage participation, and tools were put into place. But lest we take too much credit for crafting an encounter, it

should be said with great certainty that Open Field only happened because people showed up, open and willing to improvise and engage with one another. Many compared it to the seasonal and temporary pleasures of summer camp, while one participant likened it to the story of Brigadoon, an enchanted Scottish village that appears for only one day every one hundred years. For while there were moments of amazing spectacle—an opera for dogs, a silent film that drew an audience of thousands, or the surreal site of local LARPers engaged in fantasy games—the field's true enchantment arose from the practical undertaking of people coming together week after week, gathered in small groups around picnic tables, some knitting, some drawing, building something, listening to someone read a poem aloud, casually moving among others, talking, having a beer, just observing, or simply horsing around on the field. "To inhabit a place is to dwell there in a practiced way, in a way which relies upon certain regular, trusted habits of behavior," writes Daniel Kemmis in his eloquent book *Community and the Politics of Place*:

> In fact, no real public life is possible except among people who are engaged in the project of inhabiting a place. If there are not habituated patterns of work, play, grieving, and celebration designed to enable people to live well in a place, then those people will have at best a limited capacity for being public with one another. Conversely, where such inhabitory practices

are being nurtured, the foundation for public life is also being created and maintained.[8]

"Open Field reminded me how removed I've become from play," wrote one participant. "Humor can get us through the workday, but for play, we need other people and the willingness to suspend all self-consciousness with them."[9] Open Field reminded me of the fundamental ways in which we actually enjoy *being together* — playing, sharing, creating, conversing, daydreaming, and socializing. In this regard, it has changed the way I view my work as a curator and educator and renewed my own commitment to working more locally in this place where I've lived for more than two decades. Perhaps it is more precise to say that the *people* I met on Open Field changed me by demonstrating what it means to practice forms of social and cultural citizenship based on principles of trust, generosity, serendipity, caring, and authenticity. My most humbling moment came when I tried to counsel the Swatch Team yarn bombers on creating a more "compelling" system of exchange for dealing with the hundreds of hand-knitted items they had collected and made during the summer. I was promptly interrupted and told I didn't understand at all. They didn't want to exchange with people, they wanted to "give it all away" in one celebratory moment with whoever showed up to take what they wanted or needed. I realized that as much as the institution helped give people a place, there was still plenty of opportunity for us to be put in our place.

The project began with questions about

8. Kemmis, 79–80.
9. Deborah Fries, "Plein Air: Open Book, Field, Mind: Life Lessons Learned in Minneapolis," *Terrain.org: A Journal of the Built and Natural Environment* 26 (Fall/Winter 2010), http://www.terrain.org/columns/26/fries.htm.

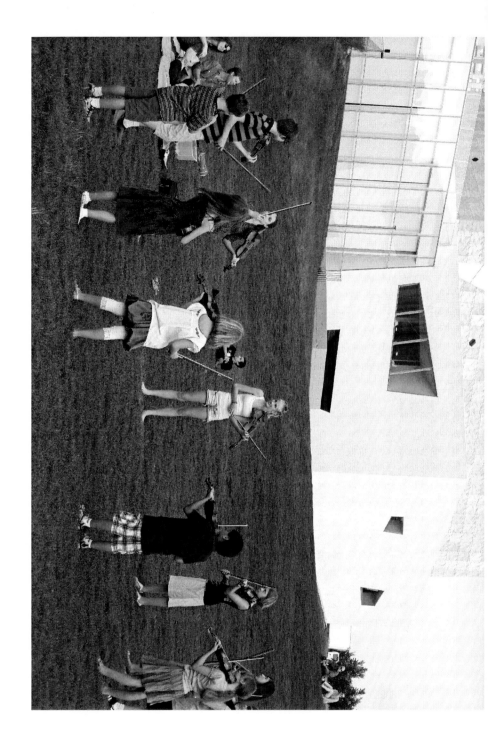

Suzuki violin students serenade visitors on the field, 2010

institutional practice and left me considering larger questions of where and how we want our public lives to unfold. What does it mean to live a generative or creative public life? How can we be more *present* with and for each other? In the quest to create a cultural commons, I stumbled upon acts of "commoning," practices of gifting rather than owning, of curiosity rather than certainty, and of generosity rather than arrogance. I wish to neither reduce nor overstate what took place on the field, but truly, if we can't sit down and make a drawing together, how will we ever make a world together?

In his landmark book *The Gift*, Hyde writes, "Both anarchism and gift exchange share the assumption that it is not when a part of the self is inhibited and restrained, but when a part of the self is given away, that community appears."[10] The inhabitants of Open Field gave generously of themselves. What tangible or intangible parts of our institutions, I ask, are we prepared to "give away," or at least hold in common so that the enchanted village appears more than once a century — or a summer?

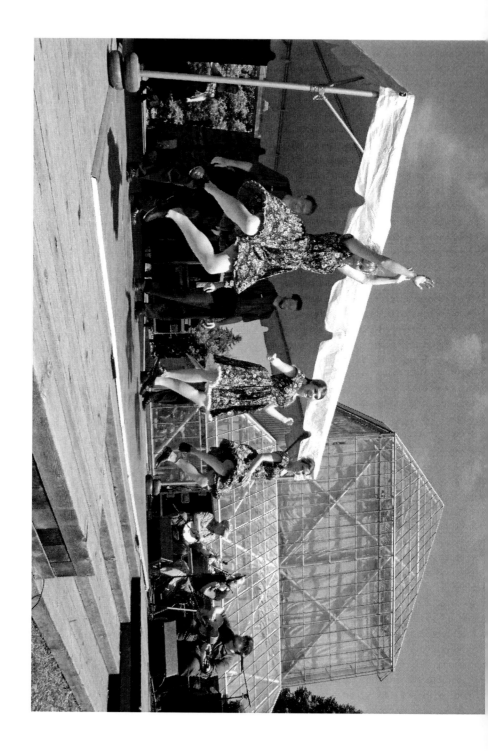

Wild Goose Chase cloggers fly off the stage, 2010

PIZZA OVEN

LARP

SQUARE DANCE

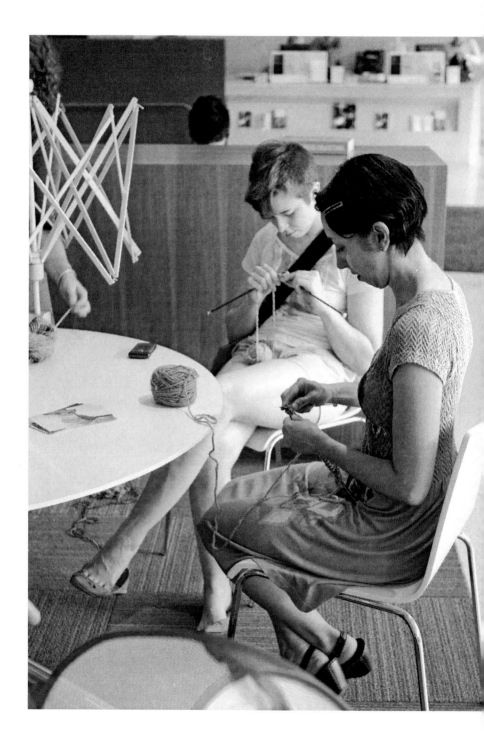

The Swatch Team offered weekly knitting lessons, collectively making and donating more than 200 handmade items that were given away at summer's end, 2011

An Authentic Commons Is Not a Temporary Affair

Interview with Rick Prelinger

Rick Prelinger is best known as the founder of the Prelinger Archives, a collection of thousands of advertising, educational, industrial, and amateur films available for public use, a portion of which are accessible online for free viewing, downloading, and remixing. A writer, filmmaker, and longtime advocate for the public domain, Prelinger was invited by artist collective Futurefarmers to give a talk on the commons for the core participants of *A People Without a Voice Cannot Be Heard* in August 2010. During his visit to the Walker, Sarah Schultz and Sarah Peters posed these questions about the relationship between commons and museums, and the complications of institutional forays into social practice.

What can the model of a commons offer an art institution?

Open Field offers us an unusual opportunity—to throw light on, and perhaps even to resolve for a time—the contentious and vexing relationship between what we think of as "art" and what we call "craft," "social practice," "maker culture" and yes, "political activity."

As civic actors, artists have been notoriously unsuccessful at causing social change on a macro level. While we've collectively helped to construct one of the most culturally exciting periods in recent history, we've had no success halting militarism, reversing accelerating economic inequalities, or grafting our values and ideas onto a working political framework. I believe we've experienced these chronic failures traumatically, and we've adapted by reconfiguring our senses of ourselves and our work to focus on smaller, more autonomous, and more achievable outcomes.

On a micro level, we've been much more successful, and our victories come in many flavors. We've taken performance into public spaces, invented new objects, planted vegetables, floated conceptual projects, sketched out utopias, and called attention to conditions that must change. This and more constitute the labor of twenty-first-century artists. We work, however, in a staccato manner: we conceive projects, we fund (or don't fund) them, perform them, evaluate them, possibly hand them over to the community, and then—we move on. Admittedly, there are exceptions, but most often we behave like

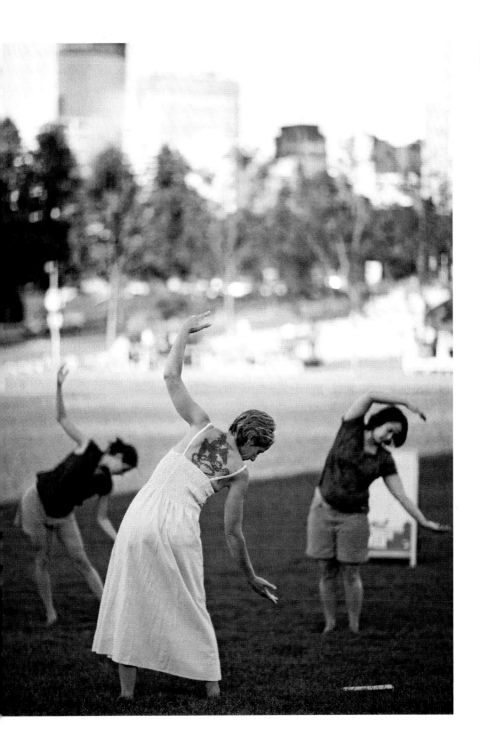

Qi-Gong practitioners demonstrate harmonizing movement on the field, 2010

serial monogamists, living as fully as we can within a moment until the next moment arrives. Our social practice is almost always short-term. We don't run community organizations; we don't build permanent workshops for makers; we do propose concepts, but we generally aren't bound by the consequences of our propositions. None of this is necessarily bad; in fact, it's quite traditional. While we work in constantly changing environments and newly emerging media forms, our social function remains much the same. And as long as these conditions prevail, Open Field will be a playground, a temporary (and not terribly autonomous) zone, incubating crops that die in the autumn and sprout again in spring.

Open Field could certainly evolve into a *bona fide* commons, or at least as much of a commons as can exist within current society, but an authentic commons is not a temporary affair. Building a place where tools, ideas, and projects are shared and money wields no power is a profoundly urgent and exciting experiment, but its success would require that we redefine what we do as artists. We'd have to move beyond a demonstrative mindset and into a productive mode, and to build a more permanent presence geared to supplying goods and services, tangible and intangible, that society doesn't currently provide. We might have to chip away at the "visiting artist" paradigm as well, because residency, longevity, and accountability are greater enablers of community. Finally, it might make sense to try to redefine privilege as an outgrowth of participation in the community, rather than individual reputation,

and find new ways to distribute agency, control, and attribution.

I'm not arguing for an end to art or for self-efface-ment on the part of artists. Rather, I imagine the commons as a space where art practice can find new meaning as it addresses deeply intractable and unsolved dilemmas. Not a single year's crop, but a field with many harvests.

Is the word "commons" a useful term? Is this concept effec-tive for creating real change?

As the term "commons" works its way into every-day speech, it runs the risk of being appropriated to describe arrangements and schemes that have little to do with collective ownership (non-owner-ship!) or shared resources. If the word goes the way of "organic" and "sustainable," we'll have an issue unless we work hard to let our practice lead our lan-guage, rather than the opposite.

What is the scale of the commons; what units do we use to measure it? Does a commons have to be intimate to be successful?

At present, commons-based initiatives are by neces-sity micro-narratives, scaled to the levels of neigh-borhoods, blocks, or grassy spaces outside museums. But the micro—the intimate—is the prerequisite to imagining the macro. While it may be frustrating to restrict ourselves to the local, it is much more dif-ficult to work toward commons-based solutions on

FLAMENCO

a grander level. This limitation is time-dependent, and I would suggest that we should enjoy working locally while we still have the freedom to do so.

How do you make the commons essential rather than a choice? How do you virally build sharing into something so that it can't be taken away?

Building sharing, interdependence, and non-ownership into a good, a practice, or a place is a most difficult problem. Schemes such as the General Public License (GPL) and the Creative Commons CC0 license make it possible to irrevocably build sharing into the core of an intangible good such as software or digital content, but few working schemes exist for tangible goods. As artist Amy Balkin points out in her piece *This is the Public Domain*,[1] our current legal regime requires that all real property have a distinct owner. We might be able to stretch intangible licensing models into the tangible world, but doing so on a voluntary basis falls far short of permanently viralizing non-owned status.

Intentionally devaluing property by rendering it overabundant or manipulating its market price works well, but can have destructive consequences. The government of Venezuela subsidizes gasoline within its borders; as of spring 2011, the price was about twelve cents per gallon, and Venezuelan society has been criticized for its overdependence on motor vehicles. Google Maps has caused the price of dashboard-mounted GPS units to drop by as much as seventy-five percent, a disruption that may

1. For more on Amy Balkin's *This is the Public Domain*, "a project to create a permanent international commons" from a parcel of land the artist purchased, see http://www.thisisthepublicdomain.org/.

threaten new product development by GPS receiver manufacturers. File sharing has made a galaxy of sounds and images accessible to a wider audience, but recording and motion-picture trade associations have responded by suing downloaders.

As we evolve new models of value and exchange, necessity is likely to play a greater role than altruism. Real-world tests that we haven't yet had to experience will measure the survivability of commons-oriented ideas.

JUMBLE

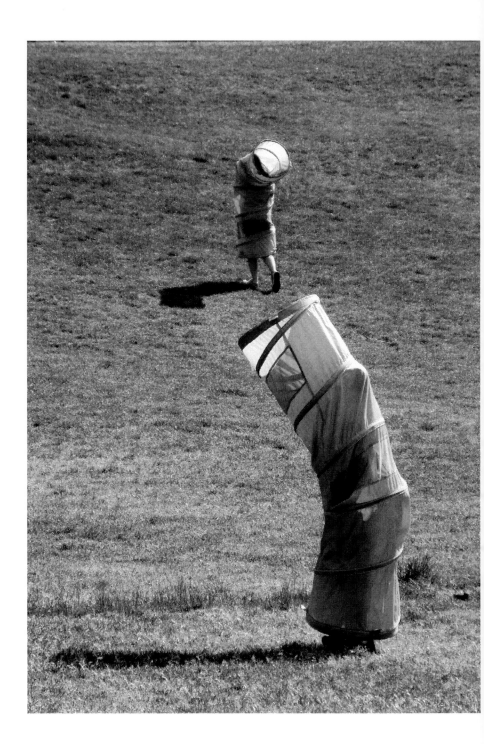

An average day on Open Field

Which Commons: Market, Zoo, or Tribe?

Jon Ippolito

This text was originally delivered as a talk at the Walker Art Center for Open Field's inaugural program in June 2010. See "Opening the Field," http://www.walkerart.org/channel/2010/opening-the-field.

INTRODUCTION

The year 2010 saw a number of prominent US museums experiment with new ways to bring their audience into the process of presenting culture. When the Brooklyn Museum invites the public to select photos for a show, or the Guggenheim teams with Google to solicit videos via YouTube, or the Walker Art Center proposes that visitors help decide what to do with the green space next to the museum, the idea of an accessible cultural commons is usually implicit. Sometimes the word commons is even in the title of the initiative, as when the Smithsonian Commons proposed by Michael Edson aims to share its virtual real estate by giving each online visitor a profile page on the Smithsonian website.

As admirable as these attempts at inclusion may be, it's important to remember how easily the word "commons" is compromised. No one seems to object, for example, when a university or hospital calls its dining hall full of McDonald's and Sbarro's a "commons." In such advertising, the word only connotes sharing; the only thing offered for free in such spaces is the seating.

In a historical sense, the commons has always been a compromise, an attempt to capture the freedom of indigenous culture in a post-enclosure state. As Joline Blais points out, the Euroethnic paradigm of the commons comes from the mostly forgotten Forest Charter provisions of the *Magna Carta*, which returned the rights of peasants to make use of land that had been abrogated by the king.[1]

The question is not whether a museum should be a commons, but which model of the commons it should be. I'll look at two models I consider highly compromised — the market and the zoo — and finish with one that I consider closest to the original spirit of the commons — the tribe.

COMMONS AS MARKET OR ZOO

Museums like to think of themselves as answering to a higher calling than mere commerce. Yet while the historical definition of the commons was all about firewood, acorns, and game you could take freely, few museums let you walk away with their permanent collections, and most charge you to walk in the door. Even museums with free admission, such as the Smithsonian, have a "gift shop" — a

1. Joline Blais is associate professor of new media at the University of Maine. See Blais, "Indigenous Domain: Pilgrims, Permaculture and Perl," http://thoughtmesh.net/publish/6.php.

contradiction in terms suggesting the unnatural yoking of free culture with a market for souvenirs.

If the way museums control access resembles a market, the way they attract visitors resembles a zoo. The word "curator" and "keeper" are interchangeable, which explains why zoos have titles like the Curator of Large Reptiles and why I once received a letter at the Guggenheim addressed to the Keeper of Modern Art. In the ideal zoo, the animals don't realize they are the subjects of other people's economic attention. In this sense, a luxury cruise is a kind of zoo, for it purports to exhibit for its passengers the world's exotic places, whereas in fact it is the passengers who are paraded around, exposed to the economic predation of local shops and tourist traps. Similarly, museums claim their value derives from the treasures in their vitrines, but as a practical matter, museums are kept solvent by the visitors who pay for tickets and tchotchkes.

When a market or zoo masquerades as a commons — which can happen with Web 2.0–style sharing networks as easily as with brick-and-mortar museums — the word degenerates into a marketing term, rather than a radical shift in access to culture.

ECONOMIC AND SOCIAL TRANSACTIONS
Comparing a museum to a market or zoo may seem glib, but if we want to treat the commons as more than a branding term we have to understand how our underlying paradigm influences the sorts of transactions — economic and social — that occur there. Transactions in a market, for example, are

based on a zero-sum economy: if I give you eighteen dollars for a CD, the assumption is that I get something worth eighteen dollars — a net sum of zero. (Bartering is a more "enlightened" version of the market because it is by necessity more local — but it is still a zero-sum economy.)

While the market runs on a conspicuously capitalist economy, a zoo runs on an invisible one. The zoo that is Facebook depends on its users blithely ignorant that the site is selling access behind the scenes to intimate details of their private life.

Each of these economic transactions produces expectations for certain kinds of social transactions. It's no secret that capitalist markets lead to wealth disparity, and thus encourage hierarchic relations that pit employer versus employee or rich versus poor. In a zoo, meanwhile, the gap between haves and have-nots is so vast that the animals can't vie with the masters because they can't even see them.

A zoo domesticates its denizens — meaning it only encourages bonds that make the animals dependent on the masters. A male tiger may be let into a female's cage to encourage them to mate, or offered fresh meat to chew. But that tiger would never be let into another paddock to drink alongside wildebeests or hunt antelopes. Yet is a tiger that doesn't hunt really a tiger?

Similarly, Facebook implicitly encourages its users to post their mating rituals on its own pages, but will sue anyone who tries to use that information on their own terms. And good luck trying to get an RSS feed out of Facebook; its founders have

no incentive to let you take its attractions home when you leave the zoo.

PRESERVATION AND GOVERNANCE

Most museums obey two contradictory models of preservation. They appraise works in their collections according to monetary value, which reflects the market-based model of ownership. Their mission statements and policies meanwhile, by discouraging deaccessioning and promoting conservation, typically reflect the care-based model of stewardship.

Ownership and stewardship share some common aims, but are fundamentally opposed in other respects. Indigenous peoples from the plains to the rainforest have traditionally assumed a role of steward for their lands, implying a high level of care and responsibility. Now that individuals and corporations can own plains and rainforests, the result has been strip-mining and slash-and-burn agriculture — suggesting that the bonus of owning something in a market system is the right to destroy it.

To be sure, a conventional museum's approach to preservation also follows the containment model of zoos. Items under a museum's care are relegated to a crate to keep them safe for future visitors to observe, and for future curators to profit from. Keeping a tiger in a cage is touted as a way to preserve its species from extinction, but just as importantly, it's a way to keep zookeepers in business.

While it doesn't have physical bars, Facebook's architecture has virtual ones: you can't syndicate, scrape, or otherwise redistribute the site's content

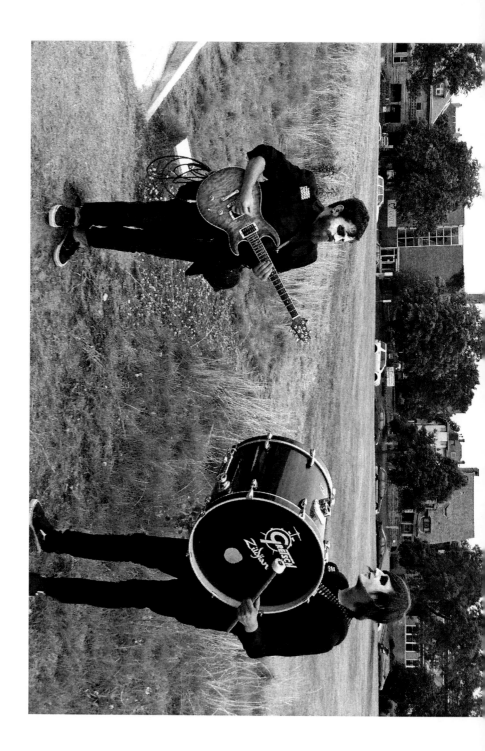

Rogue performers on the field, 2011

the way you can with blogs, YouTube videos, and even newspaper websites. Facebook's technical and legal stickiness ensures that its users will stay put inside its own pages (or quickly return to them).

If the instrument of governance employed by zoos is the cage, the instrument employed by the market is the law. Copyright is probably the most infamous example of a law that enforces a market-based approach to sharing resources. At first blush, open licenses such as those promoted by Creative Commons would seem like an alternative to the marketplace. Creative Commons licenses allow musicians and artists to share their creations within minimal strictures or via noncommercial terms. But what Creative Commons licenses convey are still rights, a form of market-based law that detaches judgment from context.

Such rights are productive in that they free consumers from the constraints of copyright, and hence from a capitalist economy. Unfortunately, they also represent a lost opportunity for the social connection crucial to the original commons. When a musician releases an MP3 on her website under a Creative Commons license, she has no way to find out who listens to or remixes it. And of course, there is little disincentive for a listener to drag an MP3 to the trash once finished listening to it — a hallmark of disposable culture that has unfortunately carried over into the physical world and its landfills full of obsolete laptops and cell phones.

COMMONS AS TRIBE

The form of commons closest in spirit to the original is not the market or zoo, but the tribe.

Transactions

If the capitalist economics of the market produce hierarchies, and the invisible economics of zoos domesticate their denizens, the transactions of a tribe create kinship. Unlike the detachable gifts of Creative Commons, the feasts and songs shared by indigenous people in potlatch serve not to disengage but to connect. In his description of the Reiti people of Papua New Guinea, anthropologist James Leach points out that those who receive gifts are indebted to those who give them—not in a zero-sum sense, but in a sense that multiplies social ties.[2] Unlike the "American Dream" promised by a market economy, you cannot work your way out of the intricate web of interpersonal debt you owe others in a tribe, even in theory.

One example of a commons that privileges connection over detachment is *The Pool*, an online environment for sharing art, code, and text currently in use by a handful of universities across the United States.[3] *Pool* users don't give each other feedback face-to-face, but develop kinship in other ways. The software encourages creators to build off each other's work, and helps visualize relationships to a work's ancestors (artistic predecessors) and descendents (works influenced).

2. See James Leach, *Creative Land* (London: Oxford Books, 2003).
3. See http://pool.newmedia.umaine.edu/.

Governance

While I will admit to projecting my own predilections onto Native culture when using the word "tribe,"it is also the closest term I can think of to describe how we got along before our common spaces were enclosed. And in some cases, the influence is direct rather than metaphorical, as in the example of the Cross-Cultural Partnership, a project developed in meetings with representatives of indigenous peoples.[4]

In the form refined by Leach and legal activist Wendy Seltzer, the Cross-Cultural Partnership is not based on an abstract right, but on a concrete context. This legal and ethical framework for sharing across cultural divides is meant to be tailor-made for each partnership, whether between a Hispanic electronic musician and a Choctaw flutist, a software artist and a Bell Labs engineer, or a Cambridge anthropologist and a Papua New Guinean herbalist.

Such partnerships emulate not the physical boundaries of a zoo or the legal rights of the market, but the protocols that allow tribes to treat[5] with insiders and outsiders alike. Protocols are essential to the functioning of a robust commons, whether they take the form of *The Pool*'s software protocols or the Cross-Cultural Partnership's legal template.

Preservation

If a market preserves by ownership and a zoo by containment, a tribe preserves by crowdsourcing. This concept has two pieces. First you have to distribute the job to more people, which means giving

4. See http://connected-knowledge.net/.
5. "Treat" is the verb form of "treaty" that I hear from scholars of native studies and international relations. Among native speakers, particularly, it conveys a sense of personal ethical behavior that has historically been denied them by paper-based colonial treaties.

up a bit on the "ownership" paradigm. The less well known but just as important second part is connecting those distributed people, which means giving up on the "containment" paradigm.

As scary as it may seem to leave preservation to such "unreliable archivists,"[6] indigenous cultures worldwide have been doing it for millennia. That's why the oldest cultural memories on the planet today are embedded not in the chiseled stones of the British Museum but in the oral histories of the Brazilian rainforest, which recount the habits and appearance of literally prehistoric creatures.

A similar approach to proliferative preservation can be found in the remix culture of contemporary digital artists, from *Joywar* to *The Grey Album*.[7] Proliferative preservation is also the basis for an experiment by the Berkeley Art Museum called the Open Museum, which makes every work of digital art collected available for remix by the public. As curator Richard Rinehart explains, "When each artwork moves into the archive, it is 'open-sourced.' Each artist decides how they would like their work represented in the archive and they allow relevant source files to be made available for download.... In recognition of the open practices that inform much net art, these source files are also available for remix, allowing these works to inspire an ongoing cycle of new artistic creation."[8]

CHALLENGES OF THE CROWDSOURCED MUSEUM
It's a lot easier for museums to give lip service to the Commons than to tear down the stanchions

6. *The Unreliable Archivist*, an artwork by Janet Cohen, Keith Frank, and myself, was commissioned by the Walker Art Center in 1998 to challenge conventional preservation practices. See http://three.org/unreliablearchivist/.
7. For more on these projects, see http://firstpulseprojects.net/joywar.html and http://en.wikipedia.org/wiki/The_Grey_Album.
8. Richard Rinehart, "The Open Museum," http://openmuseum.berkeley.edu/.

CARDBOARD

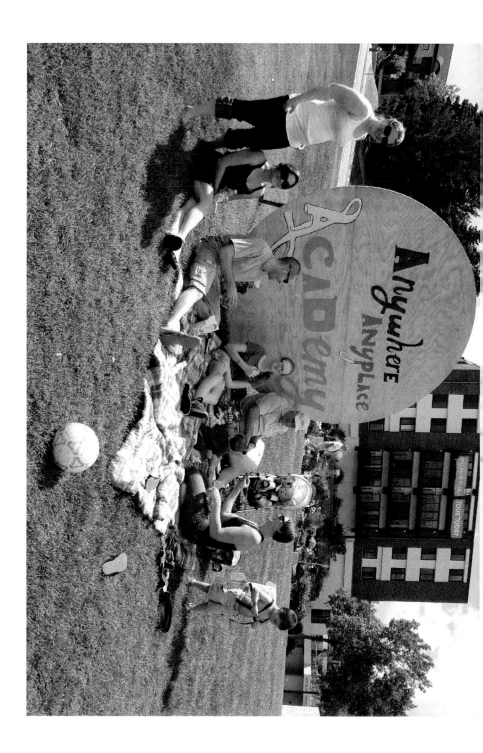

Field-goers relax in the shade of Red76's Anywhere/Anyplace Academy sign, 2010

keeping the mummies and Monets at arm's length. Yet museums must question their identity as gatekeeper, whether of the zookeeper or cashier variety, if they are to remain relevant in the age of remix.

Rinehart asks provocatively, "Do we want the public to don figurative white gloves when handling these bits, or do we want them to take them home with them?"[9] If the latter, who will safeguard the authenticity of the artifact if anyone can re-create it?

This question is understandably troubling to historians who fret about a fresco being overcleaned or a Barosaurus getting remounted in an unrealistic posture. But it should be a lot easier for curators and conservators who work with digitized or born-digital artifacts like JavaScripts and JPEGs. That's because such digital files operate by the logic not of "either/or," but of "both/and."

The most successful example of crowdsourced preservation to emerge from the past few decades is video game emulation. Amateur coders have crafted hundreds of powerful yet reverent digital vessels that "contain" vintage games' original habitats and enable them to be played on contemporary PCs. Emulator purists debate the authenticity of these re-creations with the same zeal as art historians debating the Sistine cleaning. Unlike successful conservators, however, successful emulator programmers have to conceal their identities to avoid copyright suits from the very game companies whose products they are rescuing from oblivion.

What a lost opportunity. In Marilyn Strathern's account of Papua New Guinea, creative works among

9. Richard Rinehart and Jon Ippolito, *Re-collection: New Media and Social Memory* (Cambridge, MA: MIT Press, forthcoming 2013).

its natives exist primarily to forge social bonds be-tween creator and remixer, not to antagonize them.[10] Imagine a world in which museum curators and trustees took this tribal dynamic to heart. Keepers of culture who open their gates gratefully rather than begrudgingly might find that their visitors end up caring more about things in their collections — not to mention the people who maintain them.

10. Marilyn Strathern, "Imagined Collectivities and Multiple Authorship," in CODE: Collaborative Ownership and the Digital Economy, ed. Rishab Aiyer Gosh (Cambridge, MA: MIT Press, 2006).

Contact Improvisation Jam in progress on Open Field, 2010

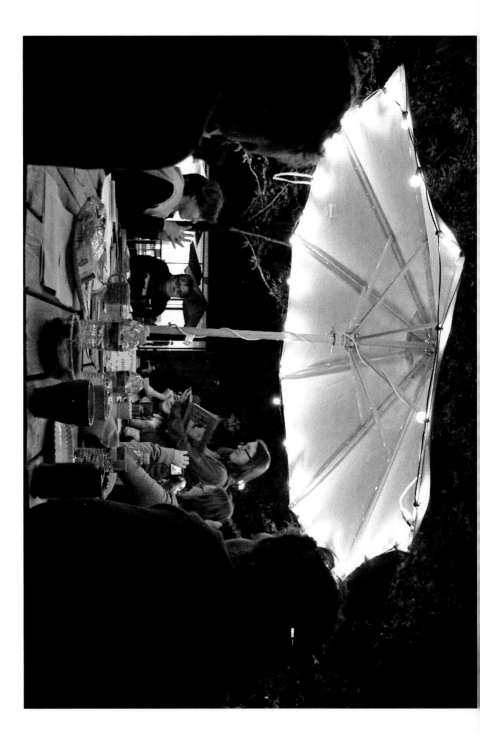

Local writers read bedtime stories on the plaza during the overnight
Northern Spark festival, 2011

The Hummingbirds perform an acoustic set inside *Sky Pesher,* 2005, the sky-viewing chamber by artist James Turrell, 2011

Amanda Lovelee's Call and Answer Project in action at the Free First Saturday Square Dance-a-thon on the field, 2011

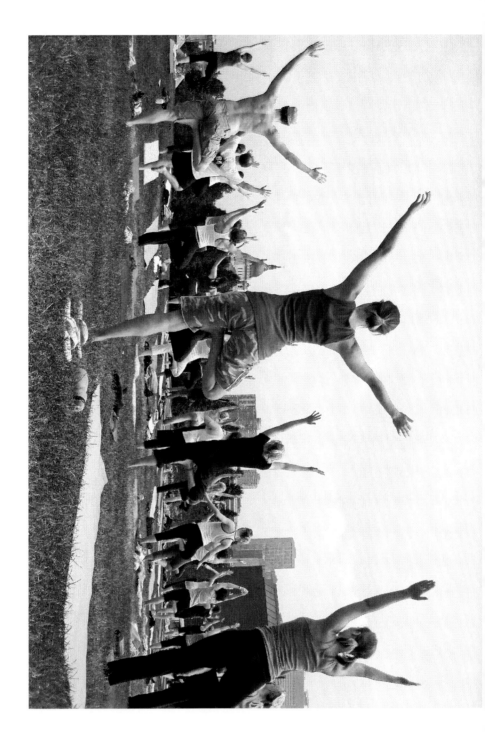

A Saturday morning in July with the Gorilla Yogis, 2010

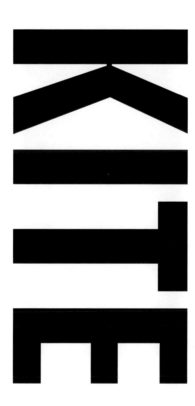

POETRY

In Defense of the Cultural Commons

Interview with Lewis Hyde

Cultural critic Lewis Hyde spoke at the closing of Open Field's first summer about his book *Common as Air: Revolution, Art, and Ownership* (2010). As a follow-up to his talk, Sarah Schultz and Sarah Peters asked him to expand on some of his ideas in writing.

Why do you think the idea of the commons has so much resonance now?

All cultures must feel friction between the individual and the group, or between public and private. In the United States, the tension seems unusually marked. At the founding of this country, we had an emphasis on "commonwealth" and we valued "civic virtue," a thing that citizens could earn by acting more for the group than for themselves. In his writings on America, Alexis de Tocqueville expressed a typical caution regarding citizens who exclusively seek their own interest: "Individualism at first only saps the virtues of public life; but in the long run

it attacks and destroys all others and is at length absorbed in downright selfishness." As for selfishness, it "blights the germ of all virtue," Tocqueville declared, aligning himself with the view that had been widespread in British North America before the Revolution. "A people is traveling fast to destruction, when individuals consider their interests as distinct from those of the public," wrote John Dickinson in 1768. "Brethren, we were born not merely for ourselves, but the Public Good!" wrote Gilbert Tennent a decade earlier.

All of this slowly changed in the nineteenth century, the center of gravity of American thought moving away from the Public Good and toward the individual who happily considers his own interests before all others. Ralph Waldo Emerson was the most eloquent spokesman for this revaluation; his essay "Self-Reliance" being one of the standard calls. "Trust thyself: every heart vibrates to that iron string," wrote the Sage of Concord. "Do not tell me ... of my obligation to put all poor men in good situations. Are they my poor?"

In my own lifetime, the tension between the individual and the collective was deeply affected by the Cold War. In the 1950s, those who sought to strengthen labor unions or the welfare state, or who worked for civil rights, were often the first to be charged with "un-American activities," if not with being actual communists. Later, Cold War rhetoric—in the '60s and '70s—had the oddly inverse effect of softening government policy toward the collective efforts needed to support the arts.

Soviet propaganda, after all, regularly claimed that the United States was a nation of crass, tight-fisted capitalists who could not possibly seek or appreciate the finer things in life. Consciously out to prove them wrong, President Kennedy invited Robert Frost to read at his inauguration and later, at the Frost Library in Amherst, [Massachusetts], defended American cultural freedoms in terms of the standard opposition to communist oppressions, extolling the artist as the "last champion of the individual mind and sensibility against an intrusive society and an officious state." After Pablo Casals played his cello at the White House, Arthur Schlesinger, Jr. declared the event "of obvious importance ... in transforming the world's impression of the United States as a nation of money-grubbing materialists." Thus, for a while, did common-wealth (including tax dollars) lend support to the private-wealth of individual creators, and to the institutions that facilitated that support.

There's much more to say in this line. (I tell the fuller story in the Afterword to the new edition of my book, *The Gift*). For now, though, the point is that it should not have been a surprise that after the fall of the Soviet Union the US Congress began to feel less inclined to soften the face of capitalism with poetry and cello music. I believe it is no accident that rigorous cuts in funding for the arts followed swiftly the fall of the Berlin Wall in the late 1980s. The market triumphalists had come to power.

That said, if the government, or "the collective" in any form, is going to support art-makers and arts institutions, it seems a shame to do so only in

response to another nation's perceived bad opinion. If we are not "a nation of money-grubbing materialists," can't the desired balance be achieved through some counterforce native to our own land and history? Capitalism may well have triumphed over communism, but that does not mean we yet know what capitalism is. Or, rather, there are many forms of capitalism, and here on home ground we should be debating what form we want.

The need for that debate and the erasure of "communism" as one pole of the argument—these two things combine, for me, to explain why we now see a growing interest in "the commons."

What does it mean to be a good cultural citizen?

First of all, it means becoming an actor rather than a passive consumer or audience member. In writing *Common as Air*, I got interested in two distinct ways of thinking of "property," common property in particular. Some people say that you know you have property if you have the right to exclude other people from it. I know I own my house because I can keep you out of it.

This is an old view; you find it in William Blackstone, the eighteenth-century British jurist, who defined "the right of ownership" as "that sole and despotic dominion which one man claims and exercises over the external things of the world, in total exclusion of the right of any other individual in the universe." (And you find it today in the views of someone like Justice Antonin Scalia, who has written that "the

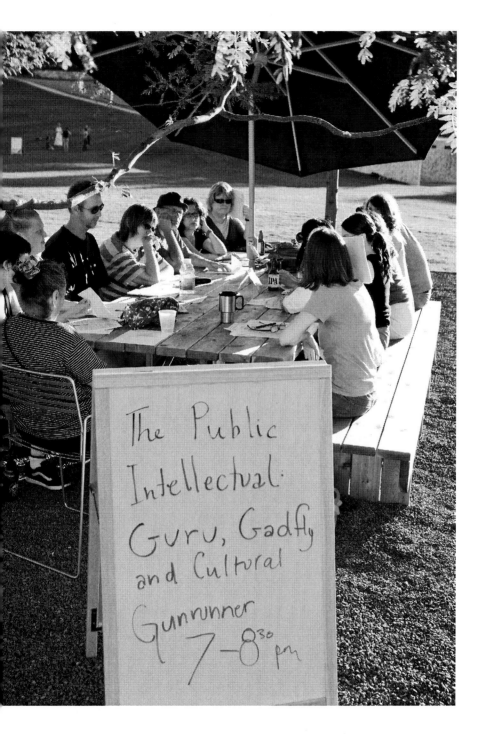

The Public
Intellectual:
Guru, Gadfly
and Cultural
Gunrunner
7–8³⁰ pm

Poet and writer Charisse Gendron convenes a reading group on the history of the pubic intellectual, 2010

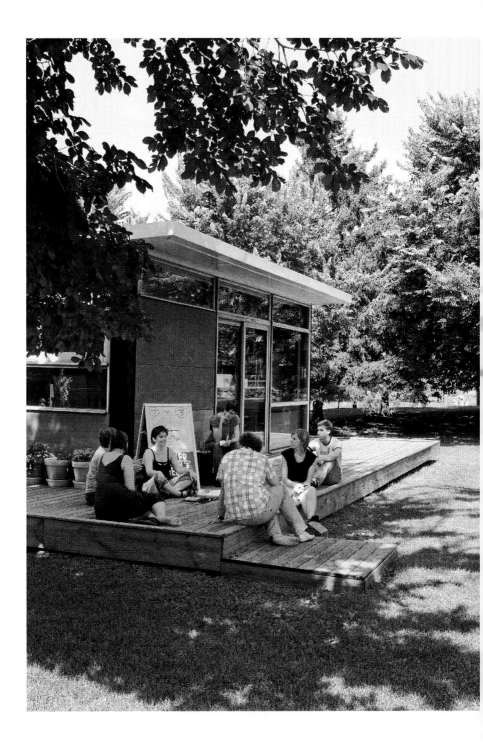

A meeting of the EcoSomatics Classroom with dancer/choreographer
Olive Bieringa in the FlatPak House, 2011

hallmark of a constitutionally protected property interest is the right to exclude others.")

A contrasting view takes property as "a right of action." I know I own my car because I may drive it, paint it, sell it, clean it, loan it to a friend, etc. My right to exclude others is one such right of action, but only one of a potentially large bundle of rights. Property in this regard is best thought of as the bundle of rights that we have in regard to any particular thing — and most of these should be thought of as rights of action. Property enables us to be agents in the world, people who act rather than find themselves acted upon.

Put briefly, what interests me in regard to cultural commons is the need to resist situations in which a right to exclude comes before the right to use. My book is largely about the history and philosophy of copyright, and copyright makes a good example. I should say, first, that I think limited-term copyrights are a good idea, the problem being how to limit them. Right now copyright easily runs a century or more and, once the rights are given, the rights holder's power to exclude precedes any citizen's right to use. Often that is not a problem, but increasingly we see the right to exclude being used as a way to shape or censor cultural expression. The way that the literary estate of Martin Luther King, Jr. has been handled is a striking case (one explained at length in the book), and there are many others.

As Carl Andre once said, "Art is what we do. Culture is what is done to us." It's the "done to us"

part I'd like the citizen to avoid; let us be the constant makers of our cultural world.

What can the model of a commons offer an art institution?

In 2009, Elinor Ostrom won the Nobel Prize in economics "for her analysis of economic governance, especially the commons." A few years earlier, Ostrom and Charlotte Hess edited a useful book titled *Understanding Knowledge as a Commons: From Theory to Practice* (MIT Press, 2007). I find the writing a bit dry, but the core material is very useful and might taken as a prompt for an institutional discussion of how to imagine a museum (or other institution) in terms of the cultural commons.

I mentioned above that traditional agricultural commons might be approached in terms of the bundle of use rights associated with them. In regard to modern commons broadly conceived (for example, including such things as irrigation systems and national parks), Ostrom and Hess offer this list of typical use rights:

ACCESS RIGHTS (the right to enter an area and enjoy no subtractive benefits, e.g., hike, canoe, enjoy nature);

EXTRACTION RIGHTS (the right to obtain resources, e.g., catch fish, divert water);

MANAGEMENT RIGHTS (the right to regulate internal use patterns and to make improvements);

EXCLUSION RIGHTS (the right to determine who will have rights and how those rights may be transferred);

ALIENATION RIGHTS (the right to sell or lease management and exclusion rights).

It would be fun to expand this list based on the actual practice of any particular institution, and then have a discussion of the enumerated rights, and of the persons who have them. One goal of such a conversation would be to think about the ends toward which the institution is dedicated. In considering ends or mission, it helps to know that a true commons is a managed thing; it operates through rules and constraints that the community develops and shapes to serve its ends in a sustainable manner. A cultural commons ought to be durable; we ought to be able to hand it on to the generations that will follow.

The field is inhabited by various celebrities and fictional characters, including pro wrestler Baron von Rashke (left, seated in convertible) and LARPer/artist Aaron Dysart (right), 2011

CHALK

TRUST

An aerial view of the Shape of Night: Busby Berkeley Nocturne event on the field during the dusk-to-dawn Northern Spark festival, 2011

Utopia Is No Place

Interview with Stephen Duncombe

Theorist and activist Stephen Duncombe was invited by Open Field artists-in-residence Red76 to give a lecture at the Walker on his work on utopia.[1] His ideas about the uses of utopia in political imagination also became fodder for the group's Pop-Up Book Academy discussion series, part of their project exploring ways to repurpose knowledge and materials. For that program, he led a conversation on collective utopia, a complicated concept in which individual dreams meet (or clash) with collective desires. Here, Duncombe discusses these ideas in relationship to Open Field in an e-mail interview with Sarah Peters in March 2011.

1. See Steven Duncombe, "Utopia Is No Place: The Art and Politics of Impossible Futures" (talk presented at the Walker Art Center, Minneapolis, July 2010), http://www.walkerart.org/channel/2010/utopia-is-no-place-the-art-and-politics-of-im.

Open Field was both praised and criticized for being uto-pian. Your book Dream: Re-imagining Progressive Politics in an Age of Fantasy *elaborates on the neces-sity of utopian thinking to reshape progressive politics. Can you summarize why you think we need this kind of imagination?*

We need utopian thinking because without it, we are constrained by the tyranny of the possible. Look where realistic thinking has gotten us: a looming eco-logical crises that may exterminate life on the planet; and a state of normality whereby the rich get richer and more powerful, while everyone else gets poorer and more powerless. This is reality, and to imagine something other than this takes a bold leap.

Meanwhile, critics of the status quo act as if criticism is enough, an appropriate response to the unfolding apocalypse that is now. They seem to believe that criticism itself will transform society. It's not that easy. Criticism is part of the very sys-tem itself. By its condition, criticism always remains obedient to the present: the object it criticizes. That is, criticism is wed parasitically to the very thing it ostensibly wants to change. There is no transforma-tive moment. Besides, liberal democracies such as ours need critics in order to legitimate themselves as liberal democracies; it's part of the system.

The political problem of today is not a lack of rig-orous analysis, or a necessity for the revelation of the "truth," but instead the need for a radical imagi-nation: a way to imagine a world different from the world we have today.

From what you experienced of Open Field, does this museum experiment relate to the idea of utopia?

I think Open Field is an experiment. You/we set boundaries: time and space, but we were also "open" to what might happen in that space. This is a good setting for Utopian imagination; you need that sort of opening to dream. Many curatorial practices function as tightly scripted spectacle with the expert directing the spectator's gaze and providing meaning. This has its functions, but Utopian dreaming is not one of them. But Open Field was not completely open. There was always some sort of impetus or prompt to organize participation: a project, a discussion, etc. And this was productive. The problem with complete openness is that it often leaves one dazed, confused, and disoriented. This is good in a way, as it breaks us out of the present, but without any guidance, the response is often to retreat back to what is safe and known—returning home to the familiarity of the very structures we were trying to escape from. If you want to stimulate imagination, it is far better to take people on a journey, give them *something* to think about, or do, or play with.

This sort of prompt pulls people out of the everyday and lets them experience an alternative reality—breaking them from the familiar and accustoming them to the strange. This is what good art does; it's what Thomas More's *Utopia* does. And (and this is an important "and") the stimulus needs to be just that: a stimulus, a prompt but not a plan. The trick is to lead people out of what they know without

simply replacing this old way of being, thinking, and seeing with a new one. You need to provide space for people's *own* imaginings.

In my notes from the discussion you led for Red76's Pop-Up Book Academy, I have written this quotation: "Let's not be practical about utopian thinking. We won't get there." I have no idea who in the room said this—which is not insignificant for a conversation on collective utopia. Can you talk about the tensions between pragmatism and impossible utopias?

"Be realistic, demand the impossible!" as the May '68 slogan went. But I want to push this idea of impossible thinking even further, to a point where I think it starts to become practical. The problem with Utopia, as the horrific social twentieth-century experiments of Nazism and totalitarian Communism amply demonstrated, is that dreams start to be taken for realities. Once this happens, there is a tendency to brutalize the present in order to bring it into line with an imagined future. We must collectivize farms, even if it kills all the farmers! This is the nightmare of Utopian history from which we are desperately trying to wake. But what if we imagine Utopia as only a dream? That is, make it something patently impossible?

This is what Thomas More does in his *Utopia*: he sketches a picture of an attractive and compelling world for us to lose ourselves within. We live in it, see it, feel it, experience it. We WANT it. And then *at the same time*, he takes it away from us by calling it

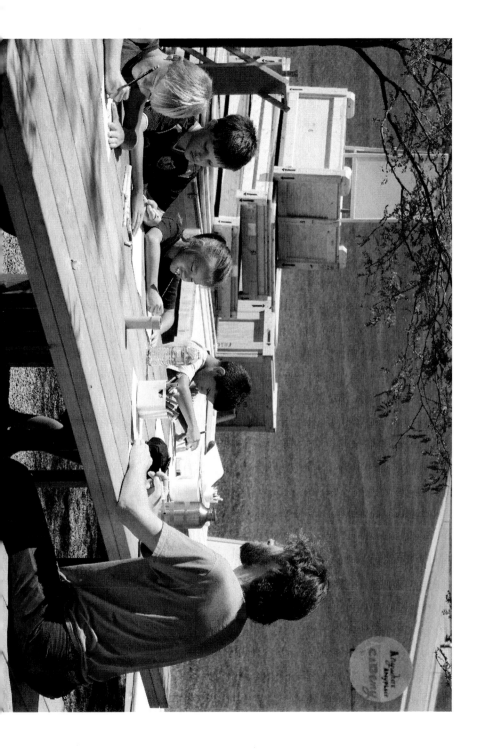

Red76 artist Mike Wolf leads young A/AA participants in a visioning
exercise, 2010

Practicing tai chi in the Minneapolis Sculpture Garden, 2011

2. Stevphen Shukaitis, *Imaginal Machines: Autonomy & Self-Organization in the Revolutions of Everyday Life* (London: Minor Compositions, 2009).

"no-place." He denies us the cathartic moment when we'd switch our allegiance from reality to a fantasy. Because we realize the dream is just a dream, this fantasy of the future cannot be sold to us as a place in which we can, and thus *must* reside (even if it kills us). And, more importantly, it forces us into a space where we can imagine for ourselves.

This sort of unrealistic Utopia in its true meaning of no-place, still retains its political function as an ideal: a loadstone to guide us and a frame within which to imagine, yet it never closes off this imaginative journey with the assertion that we are there. There is no "actually existing socialism," as Stalin had the temerity to declare. Utopia functions as what Stevphen Shukaitis has been calling an "imaginal machine."[2]

We discussed the idea of collective utopia at length during your visit to Open Field. Utopias tend to be exclusive — representing one person's or group's ideal of how society should be, yet a collective utopia would make space for conflicting visions. Has your thinking about collective utopia changed since that discussion? Was Open Field any influence?

This, I think, is biggest question I walked away with from Open Field, and it's a question that I have still not resolved. If, as I've argued above and elsewhere, the function of Utopia is not to present a vision of an idealized other world, but to prompt people to imagine another world for themselves, then how do we end up with anything besides a million and one individual and possibly incommensurate visions?

How do you get any sort of *social* change from that? The advantage of the totalitarian Utopian visions is that they were singular: you either bought in or you didn't; you either climbed aboard or you were rolled over. This is brutal, but very effective in changing the world on a mass scale.

Is there a way to envision a democratic process of Utopian imagination that leads to some sort of consensual model that, together, we can push toward and act upon? I honestly don't know, but there are glimmerings of hope in collective projects such as Open Source software development and *Wikipedia*. In both cases, there is a process of individual imagining (code, truth) and something useful comes of it (program, definition). How this process might translate from the digital to the political is still very much unknown, but I think this is a fruitful direction in which to go.

You've recently started an online project that allows anyone to use the complete text of Thomas More's Utopia *as a true commons; one that can be annotated, reorganized, and downloaded freely. Would you talk briefly about* Open Utopia?

The *Open Utopia*[3] actually began at Open Field. When contemplating the workshop Red76 invited me to lead, I though it might be interesting to "open" the text of Thomas More's *Utopia* itself by reediting it, annotating it, and perhaps writing our own version. To prepare for this, I found a public domain version of *Utopia* through Project Gutenberg and copied it

SUNSCREEN

FROLIC

into a collaborative authoring site. Reality, of course, got in the way: we ran out of time just talking about the ideal of Utopia and never got around to writing our own. But the idea stuck with me, and I decided to expand the scope of the workshop by opening it up to the digital public, building a website that would allow people to freely read, copy, download, annotate, remix, and write *Utopia*.

The first thing I needed to do was to find a version of *Utopia* in the public domain. The Project Gutenberg version was a good beginning, but it didn't contain the commendations, letters, prefaces, maps, alphabets, and marginalia of the original printings in 1516 to 1518—all of which are important to the imaginative power of the text. Luckily, a book that's been around 500 years tends to have lots of translations whose copyrights have expired, so I pieced together a new edition.

Then I thought about how I might explode the very idea of a book, replacing the author-produces and the reader-consumes model implicit in the form of a traditional printed text. In order to break this binary, I've used software produced by the Institute for the Future of the Book to enable public annotation, paragraph by paragraph. I've also created a wiki wherein a collaboratively produced new *Utopia* will be written.[4] I have channels for uploading *Utopia*-inspired art and videos as well. The whole site is produced using open-source software under a Creative Commons license.

Opening up *Utopia* is important to me because this is exactly what I think that More was trying to

do when he wrote the book. By describing this ideal someplace, but calling it no-place, he pushes the reader into imagining an alternative. More did this masterfully within the limitations of the book. I'm fortunate enough to have access to communications technology that allows me to develop this imaginative capacity of *Utopia* even further.

ACOUSTIC

Coffee House Press publisher Chris Fischbach (right) promotes reading as both a solitary and public activity for his project Reading Room in the FlatPak House, 2011

Drawing Club provided abundant, high-quality supplies for creative collaboration every Thursday throughout the summer, 2010

Drawn Together: Open Field Drawing Club

Scott Stulen

The creative process can be a private, solitary experience. Socializing within the art community can be an equally alienating activity, comprised of tedious networking at art openings and other awkward formal encounters. Drawing Club is an ongoing event at Open Field that aims for the opposite experience. Its intention is to use the simple act of drawing as a connective social platform for sharing and collaboration. Each week throughout the summer, Drawing Club invites artists and the public to gather under the trees on the plaza. Picnic tables are converted into outdoor drawing stations, outfitted with a generous array of art supplies. On the head table, a working pool of drawings from prior weeks is situated

alongside fresh sheets of paper. Each participant is invited to either start a new drawing or choose a piece in progress from the pool to alter, edit, and amend. Subject matter and materials are open; the only rule is that every drawing must contain contributions by at least two people before it can be declared complete. The finished works are collected, documented, and uploaded to the website. While many wonderful drawings are produced, the goal of the program is to create a comfortable space for artists and non-artists alike to socialize and connect. It is in many ways the backyard barbeque or local pub of Open Field—a balanced mix of regulars and new faces making work and yes, drinking beer.

In the context of Open Field, Drawing Club provides a stable, recurring programmatic thread throughout an often-fragmented schedule of events. Its scalability, openness, and simplicity make it an ideal model for such a platform. For instance, on busy Free First Saturdays, a day of family focused activities at the Walker, every table is activated; while on the occasional cold and windy Thursday evening, when the museum is open until 9 pm, it can condense to one station.

Another contributing factor to the program's sustained success is the fact that it is initiated within the local artist community. Drawing Club originated from and is organized by mnartists.org, a division of the Walker that supports Minnesota artists. Its weekly hosts are mnartists.org staff members, who themselves are practicing artists. These rooted connections provide validity and support for established

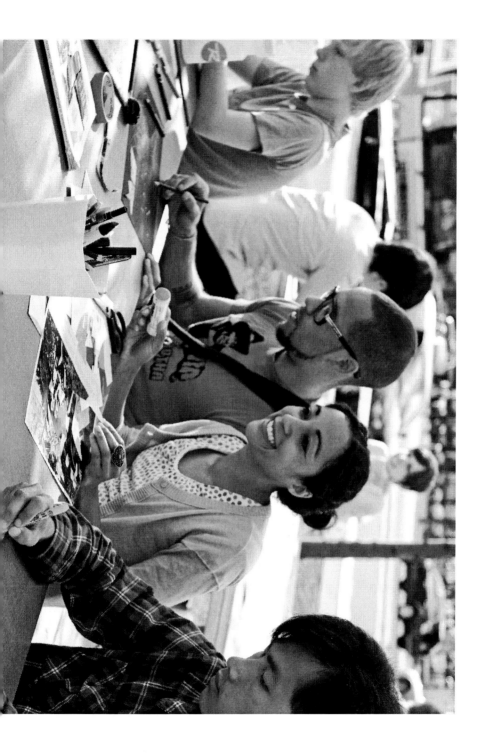

Minneapolis artists Nate Young and Caroline Kent (center) at Drawing Club, 2010

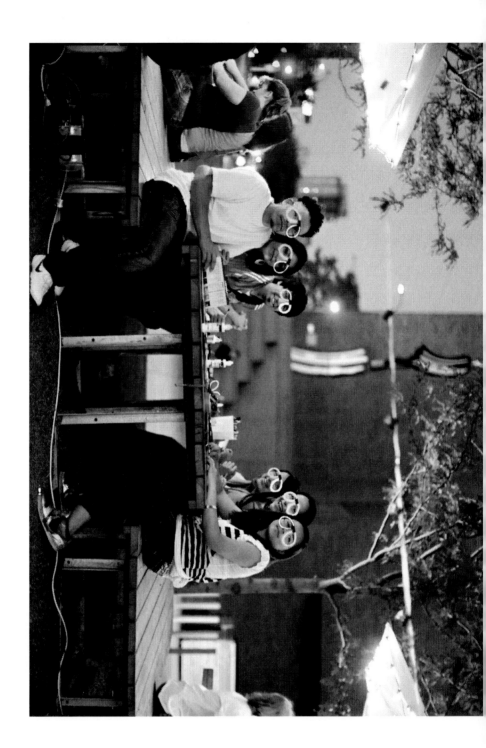

artists, while the format and anonymity of the process allow for participants of all levels to lose their inhibitions and engage without fear of exposing any artistic shortcomings. In a very direct way, Drawing Club embodies one of the core principles of Open Field by converging the institution, artists, and the public at the same picnic table.

At the Walker for the opening of his exhibition, artist Guillermo Kuitca (left) leads a drawing session, 2010

IRON POUR

HUMAN CHESS

Tapes 'n Tapes performs at the Walker Art Center Teen Arts Council's Open Exposure music showcase on the field, 2010

Car Theft for Kids workshop with Machine Project, 2011

When Bad Things Don't Happen

Sarah Peters

When Open Field launched as an expanse of grass, a set of wishful ideals, dozens of museum-organized programs, and an explicit invitation for people to come and use the space for their own creative endeavors, it also began with a set of carefully constructed parameters. Four "guidelines" and twelve "rules" governed what a person could do (share skills, be creative) and couldn't do (set up a grill, camp out, express hate speech) on the field.

These "Rules of the Commons" were a heavily debated subject within the museum. Questions of how to set up and maintain a privately owned, publicly available place played out in conversations that mirrored those you'd hear in a philosophy class. In

staff meetings, we discussed issues such as: What are the central moral and ethical tenets of free speech and assembly? Who should be able to gather, to speak, to *be* here? What exactly do we mean by "the public good"? How do we construct written guidelines to communicate all of this?

The first version of the rules was intentionally minimal as a way of better communicating a spirit of openness. These most basic behavioral directives were later expanded and made more concrete after staff imagined several nightmare scenarios that could occur in an open, public space. We posted the rules on the Open Field website, but by the end of the project's first summer, none of our fears about public misbehavior had come to pass. Political extremists did not evangelize, no one set anything on fire, and there were no trumpets played at midnight, which might have angered the neighbors. At the close of Open Field's second season, we found that the situation remained much the same. Tai chi practitioners, guerrilla knitters, and Swedish chess players took turns sharing their skills on the museum's lawn, and all did so in a friendly manner. The only ideological commotion I witnessed occurred midsummer, when a Christian flash mob cheerfully invited people to pray with them one busy Thursday night—hardly a disturbance; most people just ignored them.

Troublemakers or not, the participants who shared their creative activities on the field made good our experiment in crowdsourced content. Yet, this is not all that Open Field hopes to be. From the

beginning, we set out to create a cultural commons using the outdoor space—a physical commons—of the museum. Out of respect for the concept of *commons*, and because that word is adopted so readily to describe its antithesis (shopping plazas or the grassy sections of private college campuses, for example), I think it is important to acknowledge the root concepts of commons and to articulate the differences between them and an institutionally driven, audience-participation project such as Open Field.

Generally speaking, a commons is a resource shared by a group of people. A vast literature outlines the history and contemporary practice of these systems, primarily in the realm of natural resource management and digital culture. In a commons, a set of resources—ranging from forests to scientific ideas—is regulated and shared by groups of people, all of whom contribute to regulatory systems that sustain the stuff that everyone uses. Without going into the long history and present complexity of these models, suffice it to say that Open Field was inspired by both the oldest and newest forms of such collective resource-sharing, from rights of pasturage for grazing sheep to *Wikipedia*.

In the case of Open Field, the available resources may not be as self-evident as a grazing meadow is for animals, but we found that several tangible assets help facilitate staging an activity on the field. The most obvious of these include amenities that take advantage of the open space, such as double-wide picnic tables and shade umbrellas, an expanse of grass-covered land, and a roomy soft-surfaced

plaza that served as a stage. We also provided platforms for advertisement (analog and digital), some staff support, and social resources in the form of an audience. To that end, the museum is able to attract more substantial crowds to Open Field, which individuals working alone may not be able to gather.

The drive to make rules governing the use and availability of these resources came out of an apprehension around the very notion of "open." We were nervous about the idea of the museum's backyard being overrun by conflicting cultural, political, spatial, and aural agendas that could lead to arguments between participants, or worse, clashes between visitors and the institution concerning the messy territories of free speech. Additionally, the Walker is located in a residential area; we had neighbors to keep in mind, too.

Establishing a set of basic guidelines allowed us to venture forward into possible conflict with greater ease, primarily by determining a clear authority for the grass-as-commons.[1] In addition to some fundamental rules, we also set up a system by which people could submit their events to a vetted online calendar. This functioned as a way both to promote the public's activities and to filter out suggestions that didn't comply with the field rules (such as events that would cause sound violations) or proposals that didn't mesh with the spirit of the field (overt attempts to advertise goods or services, for example). We viewed the rules and staff-managed online calendar as tools that would allow us to live up to the "open" in the project's name, while maintaining

1. The text on the Open Field website reads: "While Open Field is a shared space, it is managed by the staff of the Walker Art Center. For the enjoyment and safety of all who visit, Walker staff reserve the right to remove any persons or activity disruptive to others at any time." See http://blogs.walkerart.org/openfield2011/about-open-field/field-etiquette/. See also pages 142–143 in this volume.

HANDMADE

OPERA

the authority to stop activity we deemed potentially dangerous or damaging to either person or property.

At first, the notion of reserving such institutional authority was uncomfortable given the stated aim of the project, for isn't everyone supposed to have equal power in the commons? Not necessarily. As scholars from the fields of economics, history, politics, and culture have stated, all commons have rules and managers. Economist Elinor Ostrom discusses them extensively in her work; in fact, she adapts commons-based regulations of natural resources to serve intellectual production in her work with Charlotte Hess, which are referenced by Lewis Hyde elsewhere in this volume.[2] Ostrom's eight "design principles" shared by successful common-pool resource management systems include: rules adaptable to local conditions, ways for most resource users to participate in decision-making, monitors accountable to users, and self-determination of the community of users that is recognized by authorities. It isn't that rules are unwelcome in the commons, but it is central to the notion that users will be able to participate in the process of decision-making about those regulatory principles. Architectural theorist Stavros Stavrides offers a similar view of the importance of user influence on governance. He posits that commons are not merely *what* people share, but also *how* they create and sustain these resources: "You have to be able to produce places where different kinds of lives can

2. See Elinor Ostrom, *Governing the Commons: The Evolution of Institutions for Collective Action* (Cambridge, UK: Cambridge University Press, 1990). For Ostrom and Hess' list of typical use rights, see the interview with Lewis Hyde in this volume, 87–95.

coexist in terms of mutual respect. Therefore any such space cannot simply belong to a certain community that defines the rules; there has to be an ongoing open process of rulemaking."[3]

These ideas about shared resources and rules are helpful in thinking about the way Open Field's participatory goals fall short. The project aims to offer a commons of culture, but it deviates from the basic principle of users' rights to participate in shaping the framework of that shared space. We didn't set up open systems for field programmers or attendees to weigh in on the structure of the overall program, nor did we build a mechanism by which they might adapt the rules in a way that better suited their projects. In fact, it's difficult to know how many people actually read our "Rules of the Commons." They were only available on the website, not in the physical space, so it's unclear to what extent any of the field's casual users knew about the governing structure of Open Field at all, or that a theory of the commons was at play in the project as a whole.

We initially put the guidelines in place in an attempt to prevent the bad things that we imagined could happen, but as the project continued, we realized the rules we established also played an important role in imparting a set of values that both reflected and helped shape the sociality of Open Field. The social operations of commons are in need of considerable attention. Ostrom and Hess' very definition of commons is "a resource shared by a group of people that is subject to social dilemmas."[4] As people negotiate using a shared space potentially for wildly divergent ends, a stated set of values

3. An Architektur, "On the Commons: A Public Interview with Massimo De Angelis and Stavros Stavrides," *e-flux Journal* 17 (June 2010): 11, http://www.e-flux.com/journal/on-the-commons-a-public-interview-with-massimo-de-angelis-and-stavros-stavrides/.

4. Charlotte Hess and Elinor Ostrom, eds., *Understanding Knowledge as a Commons: From Theory to Practice* (Cambridge, MA: MIT Press, 2007), 3.

functions as a solid foundation upon which to navigate users' differing desires.

The ethics of Open Field were more clearly articulated in the iteration of guidelines that ushered the project into its second summer. Written by Open Field coordinator Scott Artley and dubbed "Field Etiquette," this text uses the language of preservation—"Protect the Spirit, Protect the Space, Protect the People"—to communicate many of the same rules but by emphasizing values of respect, trust, and responsibility. These principles, while not foreign to the institution, are less explicitly stated or modeled inside the museum walls.

In this sense, these rules of etiquette can be read as a mission statement for Open Field. With its emphasis on creativity and community, the project's aim is similar to the Walker's core mission to be "a catalyst for the creative expression of artists and the active engagement of audiences,"[5] but it is important to note that the inside and the outside of the museum don't operate on the same principles of openness. I'm not talking about gallery admission and theater tickets (though this is a distinct and obvious difference), but about the wild territory of non-curated programming accepted outside the gallery walls. Mark Allen of Machine Project once referred to this kind of experimental programming as a "shadow institution" that operates using a different set of rules than its parent.[6] These two mission statements—inside and outside—can and should be part of the same institution.

One lesson we've learned from Open Field is not to make the galleries more like the lawn, or vice versa,

5. For the Walker's complete mission statement, see http://www.walkerart.org/about/mission-history.
6. Mark Allen, conversation with the author, July 2010.

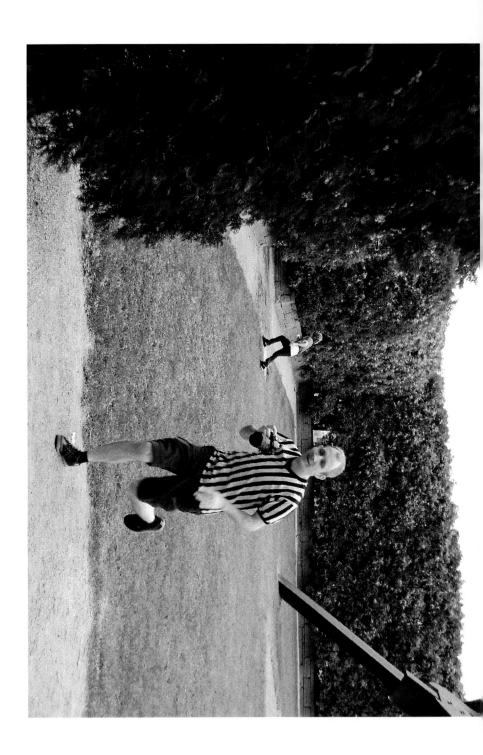

Ben Garthus officiates a game of camera tag in the Minneapolis Sculpture Garden, 2010

because each mode creates an interesting context for the other. The fact is that the inside and the outside don't hold equal power. The gallery show and the collecting of art is part of a market-oriented system of money and power set apart from the experiments playing out on the plaza, which may or may not possess the same measure of quality. However, the juxtaposition of these two spheres inevitably raises interesting questions about how and why we value culture.

In my earlier list of Open Field's resources, I neglected to mention an important one: cultural capital. This is a complicated term; I prefer the old-fashioned word for it, *prestige*. Open Field invites people to conduct creative activities in a communal space with other artists, including those chosen by the institution. Sharing a resource such as institutional prestige doesn't happen easily for museums that have traditionally played the roll of gatekeepers of culture. This proved, in fact, much harder than making rules to outlaw infrastructure damage and hate speech. It's not unreasonable that the museum asks people not to do bad things such as pounding stakes into the sprinkler system or throwing cruel epithets at each another. But what do we do if they come to the field and make bad art? Or, what if the activities they present aren't art at all?

Herein lies a challenge for institutions that employ criticality as a necessary function of their program. At Open Field, the judgment of "bad" is reserved only for actions that damage the environment, either literally or by violating the trust of its

community of users; this is much the same way that other commons operate. On the field, people share picnic tables and join each other's programs. Crafters who might not otherwise find an open invitation at the museum come every Thursday for knitting club. A wide variety of forms of expression are welcomed and presented. There is enough room for everyone, so long as they respect the space and their fellow inhabitants. In this sense, the Open Field commons illustrates what David Bollier calls "a flexible template for talking about the rich productivity of social communities"[7] as much as it is about sharing the physical resources of the site.

This way of operating effectively debunks the mindset of false scarcity informing the way many institutions dole out, or protect, their cultural capital. Open Field posits that there is plenty of prestige to go around, if we simply shift the way we view the ownership of ideas. Ostrom and Hess strike this nail directly on the head when they describe knowledge as a "'flow resource' that must be passed from one individual to another to have any public value."[8] Perhaps the best thing that could emerge from this project would be for the Walker to give up the notion of its cultural capital as a finite resource to be controlled in favor of looking upon its institutional prestige as an infinitely available resource, continuously renewed by all of the people who come to share it.[9]

Open Field, as a structured program of the Walker, is slated for its third and final summer in 2012. After that point, some significant questions will come into play. The museum expends a considerable amount

7. David Bollier, "The Growth of a Commons Paradigm," in Understanding Knowledge as a Commons, ed. Charlotte Hess and Elinor Ostrom (Cambridge, MA: MIT Press, 2007), 37.
8. Hess and Ostrom, Understanding Knowledge as a Commons, 53.
9. Thanks to Sarah Schultz for her very helpful articulation of this idea.

of money and time to activate the field through staffing, assistance with public activities, communications, and programming. When the sun sets on this support, what will happen to the commons we've created? Will people continue to hold dance concerts on the plaza? Will Open Field's most active users return in the absence of the social infrastructure provided by the museum and develop their own methods of organization? And crucially, would the Walker welcome them once the direct invitation for participation is no longer extended?

It is clear, in hindsight, that the urgency we felt to make rules to protect Open Field and the museum from trouble were not really necessary for the reasons that first impelled us to create them; people have not disrespected the space. The real concern turns out to be the question of whether members of Open Field's commons will continue to use the space once the institutionally sanctioned program is concluded. Each September, after the official programming ends, the public-organized activities also cease, even though the field remains open—the picnic tables sit there, and the sun still shines on the grass, even as summer transitions into fall. Does this lack of continued public engagement constitute a failed project?

Poet and historian Dolores Hayden draws an inspiring conclusion about failure in her study of American utopian societies: "But failure, I think, is attributable only to the most unimaginative experiments, and I am willing to define as a success any group whose practices remain provocative even after the group itself has disbanded."[10]

In that light, I suppose the success of Open Field remains to be seen. It was begun as a way to change the public's view of their agency in an outdoor, culturally imbued place. The challenge now for the Walker is to transition this creative usage of space from a museum-centered program to a genuinely public practice. This can only happen when the project is over, whatever "over" means for an experiment such as Open Field. My wish for its future is that this could be a space governed by a common law of creativity and an ethic of trust, and that it be tended lightly by its institution and ruled by its users.

Local artists host an iron pour, 2010

WHAT IS FIELD ETIQUETTE?

Like all spaces designated for public enjoyment, it is important that participants follow a set of collectively understood conventions that protect the space, the people in it, and the spirit of collaborative ownership. In this spirit, please follow these guidelines when planning your visit and activities.

PROTECT THE SPIRIT

1. All events are free and open to the public. Commercial promotion (such as coupons), sales (including merchandise), and direct solicitation have no place on the field. However, Open Field encourages sharing, bartering, swapping, and creative non-monetary exchange.

2. Open Field is a public domain—what emerges is owned by every-one and no one at the same time. Participation on the field means you are willing to share your ideas and skills with others for their personal use, inspiration, and adaptation; and you are invited to do the same.

3. Sharing the field is what it's all about. In the event of conflicts, activities posted on the Open Field Calendar will have priority, but we love it when multiple activities can coexist at once.

PROTECT THE SPACE

1. No fires, staking, digging, or other activity that could damage Open Field's physical infrastructure.

2. Containers for trash and other waste are provided; please keep the field tidy and clean up after yourself and others. Just as in all Minneapolis parks, you are welcome to bring your own food, but open containers of alcohol are prohibited. Alcohol is available from the Garden Grill by D'Amico during its operating hours.

3. Firearms, weapons, and other hazardous materials are prohibited.

4. All activities, props, and materials must be temporary. Camping or other overnight activities after midnight are prohibited.

5. All activities are subject to City of Minneapolis ordinances.

PROTECT THE PEOPLE

1. Open Field is an acoustic environment. Because of City of Minneapolis regulations, and with respect for our neighbors, amplified or excessive sound is not allowed.

2. An atmosphere of inclusion is essential—value diversity, and celebrate commonalities. Hate speech or other activities infringing on the well-being of others are prohibited.

3. While Open Field is a shared space, it is managed by the staff of the Walker Art Center. For the enjoyment and safety of all who visit, Walker staff reserve the right to remove any persons or activity disruptive to others at any time.

HAPPY HOUR

This Is Not a Trojan Horse

Steve Dietz

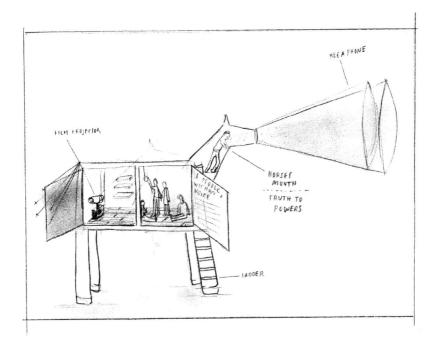

Futurefarmers' illustration of Trojan Horse as megaphone, 2010
Courtesy the artists

A voice, from the voice box, the larynx and vocal chords—actually vocal folds—is capable, with proper voice training, of oscillating 440 times per second when singing A above middle C, or simple phonation, including voiceless and supra-glottal, even sotto voce, a stage whisper, an aside, like Galileo's "Eppur si muove" ("Nonetheless, [the Earth] does move"), which voices concerns, voices doubt, voices truth, not in a falsetto voice, although what if they are only voices in your head, voices within, voice-overs, an inner voice, but maybe you are a voice in the wilderness, and that is the point, to find your voice or should you **develop** *your personal voice, whichever is your natural voice, in either case, making sure never to use the passive voice, and not just follow the siren's song, who has the voice of an angel, and you must lash yourself to the mast to not crash upon the rocks, something you only know because of a tale you heard, the voice of a bard, not discovered on* **The Voice,** *who sings what cannot otherwise be voiced, half-heard, half-known, surmised, before the age of VOA—Voice of America—or if you prefer a less moderate voice, the* **Village Voice,** *a press, and while we all know, after A. J. Liebling that "freedom of the press is guaranteed only to those who own one," maybe in the age of memes and tweets and VOIP—Voice Over Internet Protocol—vox populi, the voice of the people, assuming voice recognition and/or voice-to-text improves, will allow us to raise our voices, a flash mob of voices, an Occupy Wall Street human megaphone, but in any case, it is Voice Without Which a People Cannot Be Heard.*

This is how Futurefarmers works. There is a topic, yes. There are ideas sketched out, yes. Many sketches.

But there is seldom a fixed ending to accomplish.
During the month that Futurefarmers was in resi-
dence as part of the Walker Art Center's inaugural
season of Open Field, they led or organized multiple
activities to explore different aspects of the idea of
voice with various groups, including a core cadre of
local artist collaborators and the general public.

A girls youth choir explored Minneapolis by
voice, using song to identify the aural and psycho-
logical resonance of different public spaces. Two
workshops with the artist cadre focused on build-
ing paper megaphones with kids and their fami-
lies and low-power FM radio transmitters. Outside
experts led mini-seminars on ethnomusicology and
speech pathology. We took a field trip to the print-
ing presses of the *Star Tribune* newspaper. Public
programs featured local storytellers and films about
different voices. The monthlong experiment ended
with the event Auctions Speak Louder Than Words,
which used the epitomic economic drama and the
linguistic patter of the auctioneer to explore the
social value of stories freely told and shared.

To call Futurefarmers' process pedagogical is only
partially accurate. It is about learning, certainly.
But it is primarily dialogical. At any time, anyone
can be in the position of teacher as traditionally
understood because of his or her expert knowledge,
specific experience, particular skill, or because it's
her or his turn. But regardless of who is nominally
teaching, all participants are able to contribute to,
challenge, and thereby affect, materially, what hap-
pens next.

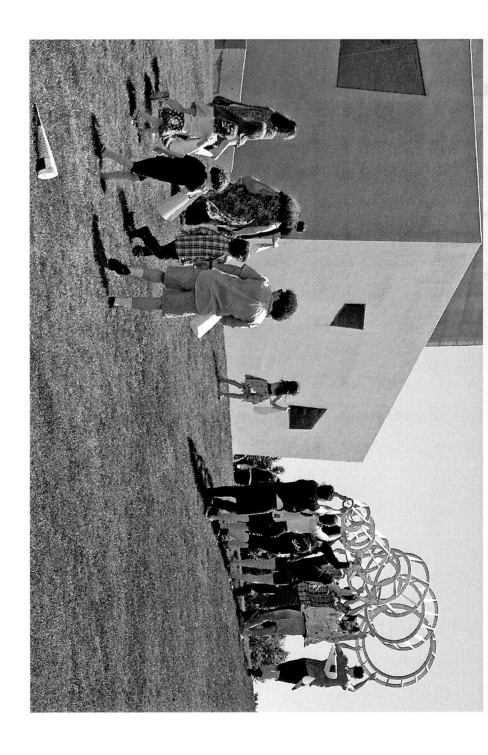

Futurefarmers' and team preparing to use the megaphone, 2010

Even more than their dialogical pedagogy, how-
ever, what characterizes Futurefarmers' practice
most strongly is its studio-centeredness. What they
make is at the heart of what they do. And the value
of craft is critical to everything they make, whether
it is smashing porcelain toilets into "clay" for new
water displacement bricks[1] or the plebeian materi-
als they used to craft the giant megaphone that was
a primary outcome of *A People Without a Voice Cannot
Be Heard*. I vividly remember an early scouting trip
for these materials with Futurefarmers artists Amy
Franceschini and Michael Swaine. Not only was it
important to make the simple gesture of shopping
at a locally owned hardware store rather than a big
box emporium with greater choice and lower prices,
but we also spent what seemed like hours discussing
the relative merits of ⅜-inch dowels and ¼-inch ply-
wood, sail and muslin cloth, and other various and
sundry items. Fortunately, afterwards it was equally
important to stop at a non-franchise ice cream joint
for a cone. And popcorn.

To emphasize the craft of Futurefarmers' prac-
tice, however, is both accurate and to do them a dis-
service. Every object they make is imbued with the
very questions they are committed to exploring. For
example, the megaphone is both a solution of how
to amplify the voice of one person to public scale,
but it also raises the question of how to aggregate
voices and not simply valorize the speech of who-
ever has control of the device. Part of the answer
lay in making an object so large that no single per-
son can transport or deploy it. It requires not only

1. Futurefarmers, *ERRATUM: Brief Interruptions in the Waste Stream*
(2010), http://www.futurefarmers.com/projects/erratum.

2. Chantal Mouffe, *Deliberative Democracy or Agonistic Pluralism* 72 (December 2000), Political Science Series, Institute for Advanced Studies, Vienna, http://users.unimi.it/dikeius/pw_72.pdf.

collaboration, but also a kind of elaborate, if informally choreographed performance, which in the end is perhaps the core message of *A People Without a Voice Cannot Be Heard*. As the Occupy Wall Street protests have amply demonstrated, it is as much about the group performance of speech acts as any specific set of words that is both unsettling and inspiring. And now it has become part of the library's collection and can be checked out. It is a public megaphone.

This leads to the final point I would like to make. While Futurefarmers is motivated by many concerns, environmental, economic, and political, *A People Without a Voice Cannot Be Heard* was never about a narrowly defined issue and especially not about a specific "answer" to that issue. The project, the methodology, the topic itself are all a platform and a set of tools, which do not have a predetermined outcome. Futurefarmers recognizes and values that humans are passionate animals, and rather than trying to quash this passion in the forced embrace of a shared response, one of the most significant ways to honor democratic ideals and the ideas of others is not to assume that there is one "right way." As philosopher Chantal Mouffe suggests, "Taking pluralism seriously requires that we give up the dream of a rational consensus.... [T]he constitution of democratic individuals can only be made possible by multiplying the institutions, the discourses, the forms of life that foster identification with democratic values."[2] This is something that art can do. Multiply points of view. Practice diverse forms of discourse. Sustain different ways of living. This is Futurefarmers. And not a bad way to think about the Open Field.

SING

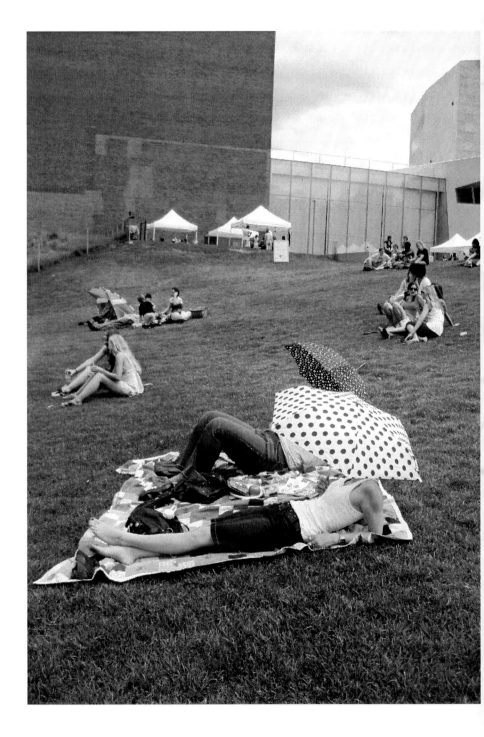

A People Without a Voice Cannot Be Heard

Interview with Futurefarmers

A gramophone, two giant chalkboards, a colossal megaphone, custom-printed money, a forty-eight-hour newspaper, a pirate radio station, an ethnomusicologist, a choir conductor, an auctioneer, a film archivist, and fifteen college students. For three weeks in late summer of 2010, the animate and inanimate came together to tell the story *A People Without a Voice Cannot Be Heard*, a project by Amy Franceschini and Michael Swaine of the San Francisco–based artist collective Futurefarmers and co-commissioned by Northern Lights.mn. Working alongside a core group of local art and design college students and guest practitioners from various fields, the artists established a temporary classroom investigating how voice is used as a tool for exchange and liberation.

1. Lorraine Daston and Peter Galison, *Objectivity* (New York: Zone Books, 2007), 24.

The collective designed a series of objects and public events to raise the expression of the people, including a large, mobile, multiple-person voice box and an auction that invited young and old to share stories and assign value to personal objects through a system of bartering and exchange. Sarah Schultz talks with Franceschini and Swaine about the relationship between their work and the commons.

Sarah Schultz: What about the idea of the commons interests you?

Amy Franceschini: I am interested in the idea of a common language formed through a collective practice that works toward a shared, open knowledge base: an open field. Think of the use of Latin in naming plants. This universal language is shared by botanists worldwide. Also referred to as binomial nomenclature, it situates a plant within a family and its relatives—a sort of belonging—"a dictionary of the sciences of the eye."[1]

While Latin plant language is primarily used by "professional" botanists as a basis for communication and building knowledge about the plant world, there is also a "common" naming system that usually describes a plant in terms of its visual appearance, smell, or habits within its environment. This common language, nuanced and specific to various cultures, is also referred to as "folksonomy."

What interests me about these naming systems is the attempt to create a shared language in the pursuit of shared knowledge: a human desire to

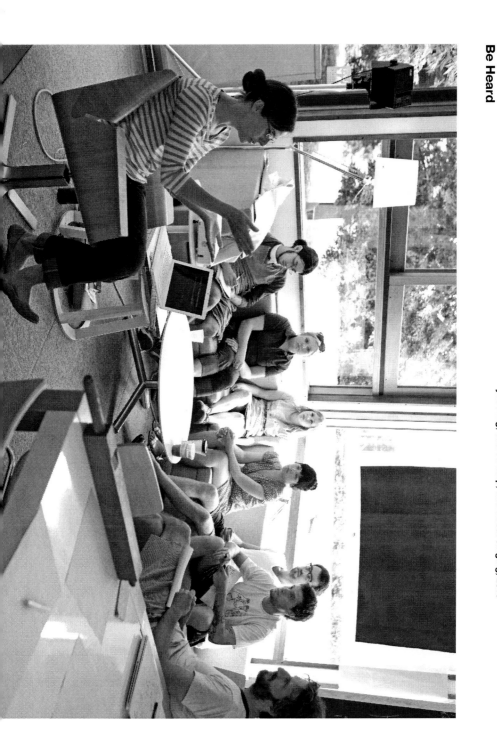

Ethnomusicologist Allison Adrian, with the Futurefarmers and team, leads a discussion in the FlatPak House about the vocal traditions of yootzing, yodeling, sacred harp, and throat singing, 2010

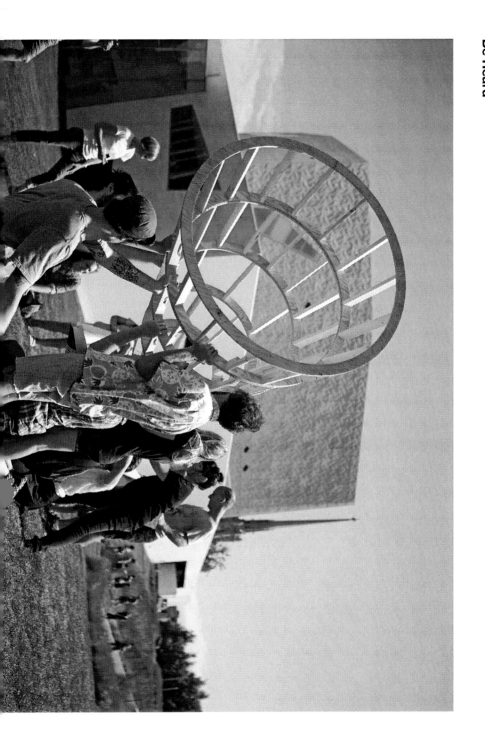

Futurefarmers and team prepare to assemble the jumbo megaphone on the field, 2010

communicate what we know and to share this knowledge for a "common good." But what is good in one scenario (time and place and people) may not be good in another. I think these variances are what interest me about the commons—the uncommonness.

Does any of this influence the way you think about your work?

AF: Joseph Beuys, during his *Energy Plan for the Western Man* tour, talked about how creativity is central to change or evolution and that it should not be limited to "a narrow group of specialists called artists."[2] His ideas have resonated with me for years, and Futurefarmers as a project embodies this concept. We are interested in forming groups with people from different fields and ideologies who come together to *make* new work. Oftentimes, a disparity of backgrounds and approaches is present in the group, which prompts everyone to see through new eyes. In Vera John-Steiner's book *Creative Collaboration*, she speaks of a "co-creation of knowledge." She writes, "Generative ideas emerge from joint thinking, from significant conversations, and from sustained, shared struggles to achieve new insights from partners in thought."[3]

Our work is very process-oriented and hands-on. We find that connecting the mind and hand is imperative. We often create open spaces for production that welcome improvisation and the idiosyncrasies of collaborators. The "making" with

2. See Caroline Tisdall, "Beuys in America, or The Energy Plan for the Western Man" in *Energy Plan for the Western Man: Joseph Beuys in America, Writings by and Interviews with the Artist*, ed. Carin Kuoni (New York: Four Walls Eight Windows, 1990), 8.
3. Vera John-Steiner, *Creative Collaboration* (New York: Oxford University Press, 2000).

other people creates a space for exchange and the experience of entering into something that does not have a known outcome.

Michael Swaine: I think my influences have grown out of the streets; this place where people bump into each other is always full of potential. Often I think of air conditioners as a symbol of what technology and architecture bring us. A small box that attaches to our window, partially blocking our view to the outside world, softening the effect our environment has on us. If we walk outside, we are hit by the sun and the smell of the city. I think it is this shared experience without air conditioners. An open space needs the potential of being unpleasant for being un-conditioned.

Amy, several times during your project you mentioned the notion of the temporary commons. What did you mean by that? What is the power or impact of the commons (or community) that is momentary?

AF: I think we have been conditioned through logics of tradition, national heritage, and so on, to hold onto ideas and fight to protect and continue things. We have a tendency to want to replicate moments of wonder, so we now spend so much time documenting and pushing those moments to other publics that the very moment is no longer experienced in real time.

For example, I live in the oldest artists' community in the United States. It began as a squat in the 1970s.

Futurefarmers collaborators Anthony Tran and Annie Wang build a
radio as part of the workshop Unregulated Radio: The Promise of the
Democratization of Media, 2010

Word was out on the streets that artists could live for free in an old warehouse. Slowly the vacant building became active and occupied by radical artists and thinkers. The floors were all open and people just camped out wherever they pleased. As more people came to the building, they began to draw lines with chalk on the ground to demarcate personal spaces. Slowly those lines became walls and then rooms with doors and then doors with locks, etc.

For a moment, there was utopia; truly shared space without notions of ownership or definition. But as soon as the chalk went down on the ground, so did pages of bylaws, legal issues, and broken friendships. Through years of negotiations, the building still lives, but the spirit of those days is only portrayed in historic photos in the hallways and on the occasional work day when ten or so of the one hundred twenty residents come out to contribute sweat to the common areas of the building. These days are the most inspired, communal, and democratic. On these days, we are mostly dealing with a broken utility that would normally be expensive to fix, but those who show up work together to come up with ingenious, ad-hoc methods to fix the problem. This shared moment of physical labor coupled with ingenuity creates a bond. Maybe this is another form of a temporary commons—the moment, not the preconception or the product, but the moment of shared production.

Your project was rooted in the notion of voice. I was particularly taken by the role of stories and storytelling

4. See "Jonathan Swift on the Difficulty of Talking with Objects" (1726) in *Making Things Public: Atmospheres of Democracy*, ed. Bruno Latour and Peter Weibel (Cambridge, MA: MIT Press, 2005), 44.

throughout the project. What are your thoughts about the role of storytelling in creating a commons?

AF: Again, this comes back to language. The idea of a shared language was connected to our interest in the Jonathan Swift story "On the Difficulty of Talking with Objects." In this story, three professors are in conversation about how to improve their country. They propose to shorten discourse by cutting Polysyllables into one and leaving out Verbs and Participles, "because in reality all things imaginable are but Nouns."[4] The other scheme was for entirely abolishing all Words.

What I think Swift might be getting at in this text is that things are not only nouns. In fact, nouns might just be a quick way of incorporating a whole lot of meaning into one thing. A building is a noun, but a building is so much more than the word. And if you are to use only objects to express the meaning of a building, you would need many. So in one way, language can replace the physicality of things and express nuances and misunderstandings that make life so interesting.

MS: Stories are a wonderful example of the advantages of creating with a material that is cheap. For the Open Field project, we started with the voice as an idea and a way to pick up a material that everyone could in some way feel connected to. We had another idea about using gold. Let's say we took $40,000 worth of gold and put it in a big pile on the lawn of the Walker. Then if we traded the gold for

lead, we would lose some of its value, as some of it would be transferred to the people involved in the trade: truckers, guards, commodity traders, etc. So then we'd have $33,650, and we'd turn the lead into silver, and then into diamonds, and then into saffron, and so on. Then we'd be down to $27,121, and it would have all happened within a week of moving and melting. As the show progressed, the pile would change shape and material, but it would also slowly shrink until it would have vanished. We'd have nothing left except the story in words—and not the printed word, as that would still be a material cost—but the spoken word. This is the material left when all else is gone: the voice. We have the words in the air that remember the gold turning into lead.

In our conversation with author Lewis Hyde, Amy brought up the notion that the commons must be practiced. Michael called this an act of citizenship. Can you expand on these ideas? Do you think that participating in projects such as **A People Without a Voice** *or* **Open Field** *is an act of citizenship?*

AF: I think it has to do with presence and participation, not just in an art project but in life; your city, your friends, your family. In the wake of the Occupy movement, this idea becomes even more relevant. People are coming together in public spaces, speaking with their bodies. Right now their presence is the most important aspect of the movement. It is a call to action. Their "lack of direction" (as described by the media) and openness in the General Assembly

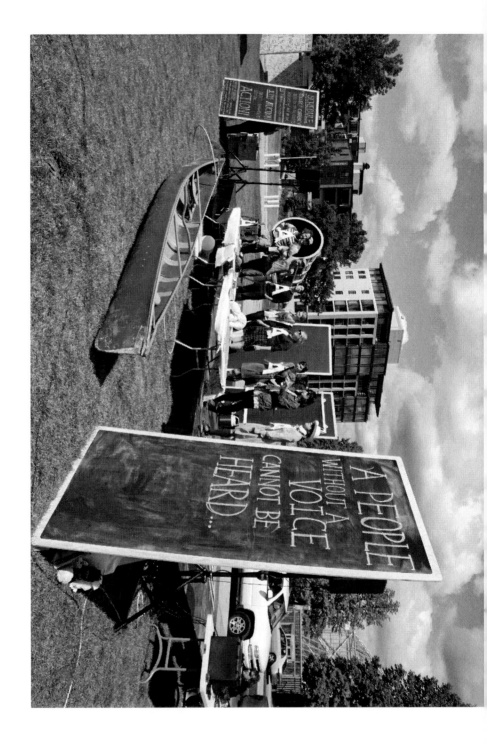

Futurefarmers and team direct a public auction at Free First Saturday in which objects, stories, drawings, and custom-printed money were bartered and exchanged, 2010

Ben Desbois (left), Robin Schwartzman, and Justin Spooner (right)
presenting the Futurefarmers' marionette show *Balls*, 2010

meetings allows for a large cross section of ideas, struggles, and concerns to be heard. It is a space to share and understand each other's varying perspectives. I am not sure this is an act of citizenship. "Citizenship" implies a certain exclusivity. Maybe we need a new word.

I think there is something here about the importance of dialogue in a democracy—perhaps as a form of citizenry? The idea of practice implies an embodied experience or action with intention. It is one thing to practice alone, but as Jim Melchert once said, "Conversation allows you to hear for the first time a thought you had."[5] I think this exchange is where form and meaning emerge—where disagreement can occur, assumptions can dissipate, and true change can happen. But to take the dialogical exchange a bit further into a material articulation of ideas—from mind to hand in collaborations with others—ideas can be seen, inscribed, and openly interpreted. "To see an idea is to forget its name, thus a new or shared meaning can emerge."[6]

MS: I think *A People Without a Voice Cannot Be Heard* was more on the side of teaching than politics, but teaching is a great example of a place that has such an important role in both citizenship and politics. If we are not taught to speak, then we will not know how to yell our protests. School should be a place where we learn how to speak freely.

5. Jim Melchert quoted by Mary Jane Jacob, "The Space of Art," in *Buddha Mind Contemporary Art* (Berkeley, CA: University of California Press, 2004),164.

6. Paul Valéry quoted in Lawrence Weschler, *Seeing Is Forgetting the Name of the Thing One Sees: A Life of Contemporary Artist Robert Irwin* (Berkeley, CA: University of California Press, 2008), 207.

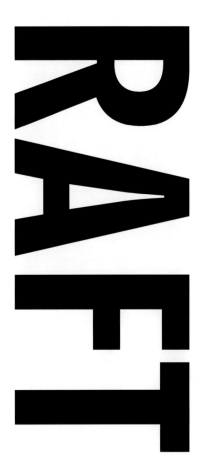

RAFT

If We Had a Hammer

Interview with Red76

In midsummer of Open Field's first year, museum visitors encountered scrap wood, hammers, drills, and saws on the lawn for their use. These tools were a part of Surplus Seminar, a project organized by artist collective Red76 to explore ways that we repurpose knowledge and materials by giving people an opportunity to activate their dual roles as consumers and creators of ideas and things.[1]

Red76's three-week Open Field residency included several components: Anywhere/Anyplace Academy (A/AA), the improvised construction of multiple schoolhouses on the field built from scrap materials at the museum; Pop-Up Book Academy (P.B.A.), a discussion series with seven guest speakers; House

1. A wayward chronicle of Surplus Seminar at Open Field, including blogs for its various components, can be found at http://red76.com/surplusindex.html.

Show as School House (H.S.a.S.H.), a set of weekly concerts at underground venues in Minneapolis that were followed by conversations on the pedagogical nature of DIY music; and YouTube School for Social Politics (YTSSP), an ongoing platform that invites people to construct video essays using material found only on YouTube. Surplus Seminar concluded with the Floating Academy, a conversation about commons that took place aboard a flotilla of handmade rafts.

This residency involved numerous people as participants and organizers. Here, the project's primary architects—Courtney Dailey, Dylan Gauthier, Sam Gould, Gabriel Mindel Saloman, and Mike Wolf—answer questions about each component of the residency in an e-mail exchange with Sarah Peters.

In keeping with the concept of a seminar, this interview includes bibliographic references for further investigation of ideas explored throughout the group's project.

Sarah Peters: The philosophy of the Anywhere/Anyplace Academy maintained that everyone was welcome to help build. What is important about the open invitation to pick up a hammer?

Mike Wolf: My thinking about this stems from three ideas about "work" in a general sense:

People like to work. The more we let ourselves be absorbed by work—though it is not always

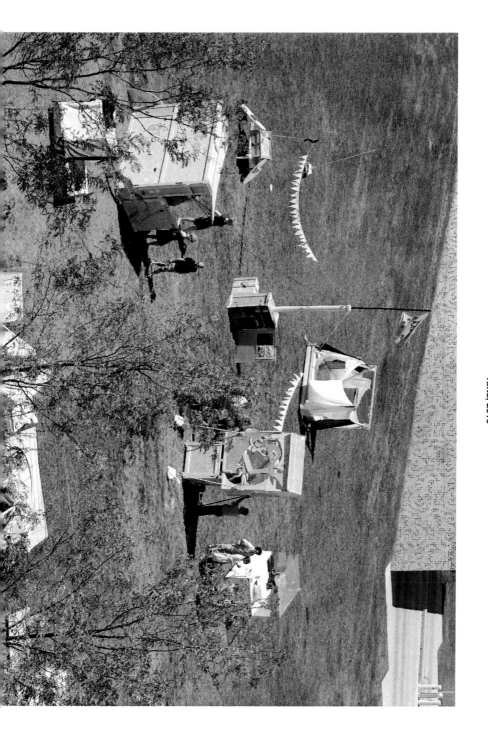

The Open Field campus of Red76's Anywhere/Anyplace Academy featuring the Quiet School, the Scribble School, the School for Human & Dragon Peace and Reconciliation, the Observatory, and several rafts, 2010

pleasant in the immediate sense—the more we experience its intricate rewards.

From some vantages, it is clear that there is plenty of work that could be done to improve conditions for more people in the world.

There are many barriers to work. Psychic, cultural, bureaucratic, and especially economic obstacles can stand between someone who is inspired to work and an opportunity to do so.

When we created a set of conditions on the lawn of the Walker called Anywhere/Anyplace Academy, we tried to create a situation that would take down some of those barriers and give bystanders a chance for their dreams to meet the material. It was an experiment and our hope was that it might reveal to us, and to the participants, a glimpse of broader possibilities for the kind of work we might do to improve conditions for people.

SP: What can we learn from building things collectively, without a blueprint?

MW: It is reasonable to say that most building is done collectively. What distinguished A/AA, to some extent, was our effort to create a non-hierarchical situation, or one that kept hierarchy turning and churning. This churning was the result not only of a self-conscious effort by Red76, but also by the project's severely unstable labor force. That is to say, the

Gabriel Mindel Saloman models a prop for the School for Human & Dragon Peace and Reconciliation, 2010

work was done and the decisions were made by who-ever showed up, but only a few people came more than once. This is not a good way to make sound, lasting structures, either in the physical or the psychological sense. But it is a good way to make crude, immediate transmutations of a lot of people's ideas, desires, and dreams on an architectural scale. It also gives people an experience of a liberated place. Albeit temporary and limited, the impressions this leaves can be profound. Like planting a seed, they can have wonderful consequences down the line.

Learning Group (Rikke Luther, Cecilia Wendt, Julio Castro, Brett Bloom). *[Collecting Systems]: [Learning Book #001]*, Chicago: WhiteWalls, 2006. http://www.learningsite.info/learning book001.htm.

Rogers, Heather. *Gone Tomorrow: The Hidden Life of Garbage.* New York: New Press, 2005.

Wilson, Peter Lamborn, ed. *Avant Gardening: Ecological Struggle in the City & the World.* New York: Autonomedia, 1999.

Wilson, Waziyatawin Angela, ed. *In the Footsteps of Our Ancestors: The Dakota Commemorative Marches of the 21st Century.* St. Paul, MN: Living Justice Press, 2006.

SP: Surplus Seminar's Pop-Up Book Academy (P.B.A.) sessions presented a curriculum of diverse, but not unrelated subjects: utopia, micro-cinemas, colonialism, magic. Were you able to pull out a common thread (or threads)? How do these ideas relate to Open Field's investigation of the commons?

Sam Gould: For me, the common thread of the P.B.A. sessions was a conversation on how we could create a common landscape. By this I don't mean a commons, per se, but a diverse ecosystem wherein

divergent opinions and relationships could coexist (maybe even thrive), working with one another but not all together in consort, exactly. Like any eco-system, the landscape that was desired, it seemed, was made up of many different parts. The dialogue in question—despite at times being made up of seemingly divergent views—came back to a space in which people attempted to figure out how to maintain individuality within the collective whole and how to maintain group affiliation within a land-scape of many different groups.

At times, these conversations were fairly conten-tious. In particular, I'm thinking of the Unsettling Minnesota P.B.A. and the last session, the Floating Academy, during which we discussed colonization and native land rights. But, despite any contentious-ness, these sessions were incredibly vital and ener-gizing for me. Not because I came away feeling like, "I'm right and they don't get it," but because I felt part of a space that generated common ground and allegiance for individuals who might not feel the exact same way about things but could still agree on others. There seemed to be this agreement, over-all, that we all could trust one another in regard to certain issues and that we could figure out the rough edges as things went along. And, I feel like it's important to reiterate—THERE WERE A LOT OF ROUGH EDGES!

Also, Stephen Duncombe, both in his lecture and P.B.A. session regarding his ideas on utopia, summed up the entire project for me very well. The session further solidified my notion that work such

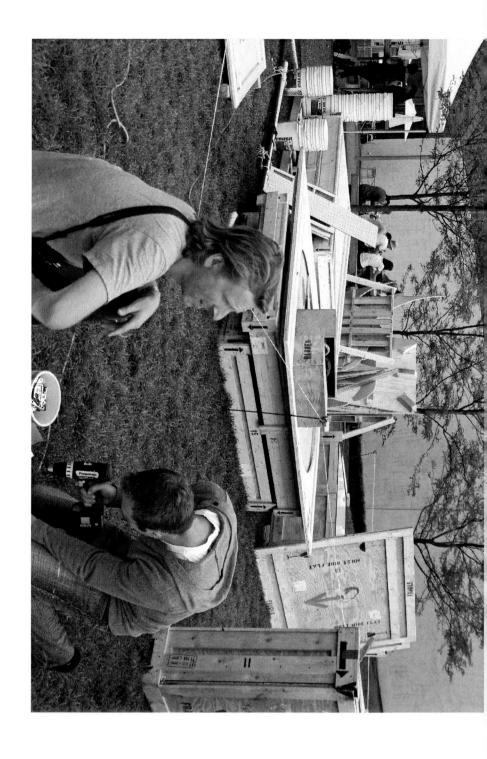

as this needs to be seen as a vehicle, not a far-off goal. It's not pessimistic, or nihilistic; the work is a tool, a means toward allowing ourselves to venture off into the distance and attempt to reach a place that, truthfully, might not exist at all. But what we discover along the way is what we're actually after, and it's really hard to come to that realization.

Daniel, Bill. *Mostly True: The Story of Bozo Texino*. Lansing, KS: Microcosm Publishing, 2008.

Duncombe, Stephen. *Dream: Re-imagining Progressive Politics in an Age of Fantasy*. New York: New Press, 2007.

Madoff, Henry Steven. *Art School (Propositions for the 21st Century)*. Cambridge, MA: MIT Press 2009.

More, Thomas. *Utopia*. Public Domain Books, 2000. Kindle Edition.

Okakura, Kakuzo. *The Book of Tea*. New York: Fox, Duffield and Company, 1906. Public Domain Books, 1997. Kindle Edition.

Pentecost, Claire, Jessica Lawless and Sarah Ross, Lisa Bralts-Kelly, Brett Bloom and Bonnie Fortune, Ryan Griffis, Mike Wolf, Martha Boyd and Naomi Davis, Rebecca Zorach, Nicolas Lampert, The Langby Family, Eric Haas, Sarah Holm, Brian Holmes, Dan S. Wang, mIEKAL aND, and Sarah Kanouse. *A Call to Farms: Continental Drift through the Midwest Radical Culture Corridor*. Viroqua, WI: Heavy Duty Press, 2008. http://www.heavy dutypress.com/books/farms_pdf/view.

Stadler, Matthew. *Chloe Jarren's La Cucaracha*. Portland, OR: Publication Studio, 2011.

Unsettling Minnesota. *Unsettling Ourselves: Reflections and Resources for Deconstructing Colonial Mentality*. Self-published sourcebook, 2009; second edition, 2010. http://unsettlingminnesota .files.wordpress.com.

SP: The YouTube School for Social Politics (YTSSP) shifts this ubiquitous website from the realm of entertainment into education. As a YTSSP author, what is the value of mining this content to construct a thesis? What can you make from these "surplus" videos that you can't replicate in a traditional essay?

Courtney Dailey: For me, the process of constructing the YTSSP was a meandering, self-directed one that

began with a question about YouTube and learning: how could immersion, as a pedagogical strategy, be represented on YouTube? I was interested in seeing what might be gained, and perhaps lost, by watching videos as a way to learn.

The URL collections made for the YTSSP have a particular quality: they tend to look more like an exhibition or a time-based collage than an essay. Looser connective threads exist and are allowed to stay that way, in contrast to the traditional demands for argumentation and structure in academic or journalistic essays. In its live presentation, the YTSSP feels a bit like a lecture, and a bit like a bunch of folks hanging out. This casual nature feels exciting and convivial, but still somewhat rigorous and thoughtful.

Red76 asks that the curators record a short introductory video to frame their selections, which essentially functions as the "wall text" of the essay/exhibition. In the YTSSP online, the viewer is invited to experience the videos in succession (or not), and connect them together (or not) through the lens of the curator's video (or not). The format is inextricably linked to Red76's obsession with surplus, in myriad forms. YouTube is clearly a container of surplus knowledge, time, energies, and enthusiasm (more than twenty-four hours of videos are uploaded every minute, according to YouTube), so it seems only fit to mine it to construct some kind of associative narrative.

Structurally, I believe it proposes a way toward research and presentation that feels open, connective, and leaves room for the viewer/reader to extend

and expand the topic at hand, with a quick jump to a practically unlimited number of videos.

Bronack, Stephen, Robert Sanders, Amelia Cheney, Richard Riedl, John Tashner, and Nita Matzen. "Presence Pedagogy: Teaching and Learning in a 3D Virtual Immersive World." *International Journal of Teaching and Learning in Higher Education* 20, no. 1 (2008): 59–69. http://www.isetl.org/ijtlhe/pdf/IJTLHE453.pdf.

Duberman, Martin. *Black Mountain College, An Exploration in Community.* New York: W. W. Norton, 1993.

Koolhaas, Rem, Stefano Boeri, Sanford Kwinter, Nadia Tazi, Hans-Ulrich Obrist, Arc en rêve centre d'architecture, and Harvard Project on the City. *Mutations.* Barcelona and New York: Actar, 2001.

Lange-Berndt, Petra. "Test Site Bohemia: *On Mildred's Lane* by J. Morgan Puett and Mark Dion, Pennsylvania." *Texte zur Kunst* 21, no. 81 (March 2011): 173–175.

SP: House Show as School House (H.S.a.S.H.) forwards the notion that DIY music shows—quasi-legal musical events that happen in basements, backyards, and living rooms—are pedagogical spaces. In what ways does participation in subculture make a space for learning, rather than, say, rebellion? What links can you draw between the education in a house show context and learning through other collective endeavors, such as building a structure or discussing books?

Gabriel Mindel Saloman: I have to contradict the notion that rebellion and pedagogy are incompatible—in fact, they're inseparable—though I understand the distinction you're suggesting. The common assumption around subculture is twofold: first, that subcultures are distinct in a meaningful way from mainstream culture and, second, that the discourse that emerges from within subculture is reactionary and purely oppositional.

Red76's position is that there is no "outside" or "inside" culture, but rather that subcultures are vital veins that run the length of—and intersect with—what is presumed to be mainstream culture. The House Show is a potent example of DIY culture. It is a reclaiming of agency that attempts to turn a consumer relationship back into a producer relationship. It models itself primarily off of the examples set by mass culture.

The House Show doesn't differ structurally from an event in a major Twin Cities venue like First Avenue. The distinction is in everything else that happens that does not occur in a large concert venue. A whole set of lifeways are expressed in the context of the House Show, including an explicit set of social and political values that you must explicitly consent to or contest upon entering. Spaces such as the Bomb Shelter in Minneapolis, as one of countless examples, brought people together under the pretext of watching and performing live music, but functionally it also served to distribute and communicate anarchist consciousness and practice. Similarly, Riot Grrrl and Queercore communities imbue their cultural production and social relationships with the critiques and ethics of their respective identity politics.

I identify this process of experiential education as the House Show's primary pedagogical praxis. Importantly, this process is self-perpetuating because, by participating, you are also learning and teaching at the same time. Among the incredible number of things a person might learn and teach in

the process of participating in a House Show are: ideas around the ethics of different kinds of social relationships; the correlation between how we spend money or act as workers and the overall capitalist system; the way in which we enact mutual aid and build communities; and the exploration of alternative art worlds, art-making, and DIY practices, in general.

Azerrad, Michael. *Our Band Could Be Your Life: Scenes from the American Indie Underground 1981–1991*. Boston: Back Bay Books, 2002.

Bey, Hakim. *T.A.Z.: The Temporary Autonomous Zone, Ontological Anarchy, Poetic Terrorism*. New York: Autonomedia, 1991.

Hebdige, Dick. *Subculture: The Meaning of Style*. London and New York: Routledge, 1979.

Marcus, Sara. *Girls to the Front: The True Story of the Riot Grrrl Revolution*. New York: Harper Perennial, 2010.

Spencer, Amy. *DIY: The Rise of Lo-Fi Culture*. London: Marion Boyars Publishers, 2005.

Thompson, Stacy. *Punk Productions: Unfinished Business*. New York: State University of New York Press, 2004.

Weir, Jean. "The Struggle for Self Managed Social Space." *Deranged* #0 (2007). 12thandclark.files.wordpress.com/2011/04/sfself.pdf.

See also the punk fanzines *Maximum Rocknroll* (1982–present) and *Profane Existence* (1989–1998).

SP: As a boat builder, an urban water explorer, and captain of the Floating Academy—Surplus Seminar's finale—how do you view water as a commons? Does paddling in a handmade boat or entering waters that aren't designed for leisure, such as industrial canals, alter one's perspective of water?

Dylan Gauthier: Water is the best metaphor I can think of for this idea of a commons. We all need it to live, and creating systems that guarantee the

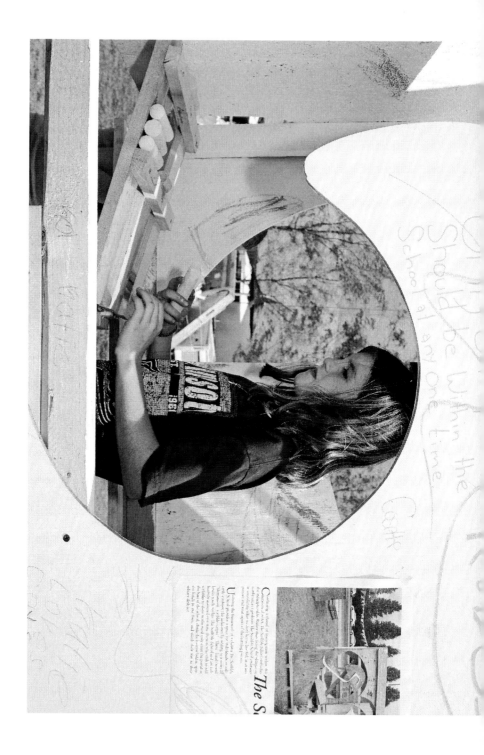

A young artist at work in Red76's Scribble School, 2010

safety and availability of this substance is among the most pressing tasks for us, if we are going to survive as a species.

On land, water is an element often taken for granted. It comes to us in the plumbed, developed world with little effort, yet is a subject of intense dispute in many places. In this country, wells and aquifers can be cordoned off as private property, but a large number of lakes, rivers, and creeks are also protected for public use. Drinking water is treated as a high-stakes commodity, priced alongside natural gas. With hydraulic fracturing, the price of the necessity (water) loses out to the more lucrative commodity (gas) at the expense of public health and the common good.

Public waterways—the lakes of Minneapolis or the shipping channels around New York City, for example—are as policed as the land around them, yet other waters are unwanted and therefore largely ignored, such as the toxic Gowanus and Erie Canals. Unfit for consumption and noxious to humans, these waters may freely be taken up as liberated spaces and occupied. From time to time, they have served as experimental real estate as well as a platform for issues such as gentrification, racism, rent gouging, inadequate public transportation, food prices, and the like.

Occupying such liberated spaces informs us of the necessity for these openings to continue to exist. Being in them for just a moment can reconfigure our perception of the possible.

Foucault, Michel. "Of Other Spaces (Heterotopias)." Lecture presented in 1967. *Architecture, Mouvement, Continuité* 5 (October 1984): 46–49. http://foucault.info /documents/heteroTopia/foucault.hetero Topia.en.html.

Pearlman, William David ("Poppa Neutrino"). *Poppa Neutrino Speaks.* Floating Neutrinos, 2001. http://www .floatingneutrinos.com/Message/Poppa%20 Neutrino%20Speaks.html.

Shiva, Vandana. *Water Wars: Privatization, Pollution, and Profit.* Cambridge, MA: South End Press, 2002.

Trawick, Paul. "Against the Privatization of Water: An Indigenous Model for Improving Existing Laws and Successfully Governing the Commons." *World Development* 31, no. 6 (2003): 977–996. doi:10.1016/ S0305-750X(03)00049-4.

Wilkinson, Alec. *The Happiest Man in the World: An Account of the Life of Poppa Neutrino.* New York: Random House, 2007.

Wilson, Peter Lamborn. *Pirate Utopias, Moorish Corsairs & European Renegadoes.* New York: Autonomedia, 2003.

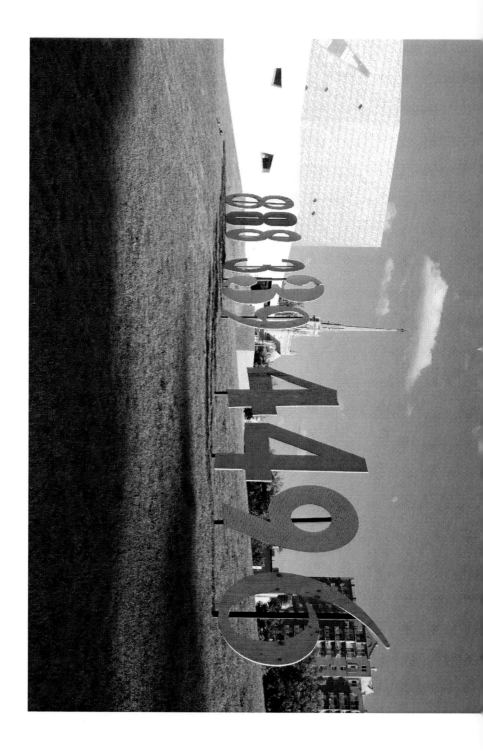

Red76's toll-free hotline on the field directed callers to get involved with
Surplus Seminar, 2010

SCHOOLHOUSE

HARVEST

Summer Jubilee

Interview with Mark Allen of Machine Project

A confederacy of artists called Machine Project, which makes its home in a storefront space in the Echo Park neighborhood of Los Angeles, descended on Open Field for the last two weeks of July 2011. In a mere eleven days, an assembly of fourteen artists and musicians entertained and educated Minnesotans through seventeen different happenings. To list the workshops, performances, and surprising delights that the group brought to the Walker—an operetta for dogs, polygraph tests for museum visitors, a car theft workshop for kids, a choreographed performance showcasing amplified riding mowers, to name a few—only begins to capture their wildly imaginative residency project called Summer Jubilee.

Both visitors and staff came to expect the unexpected when Machine Project became a kind of institution embedded within an institution, occupying the Walker's indoor and outdoor spaces in a curious, symbiotic way. Turn down a forgotten corridor nestled behind a gallery and you might be invited to bear your soul to a crew of opera-singing therapists. Exit your car in the underground parking ramp and you might stumble into a concert of experimental live music. The question of how artists work within and alongside the public—whether it's inside the highly sanctioned sphere of the museum or its less controlled backyard—is something Machine Project founder and director Mark Allen discusses with Sarah Schultz.

Sarah Schultz: Here we are!

Mark Allen: Here we are!

SS: I thought it might ground the conversation if you could talk about your broad take on Open Field.

MA: What I think works really well about Open Field is that it's a space to do projects that are not under a lot of editorial pressure from the institution. Often when I've worked in museums, I've found that you can have a theoretical conversation about the value of experimentation, but you can still feel the institution's almost psychic pain when projects go embarrassingly wrong, which itself is one of the

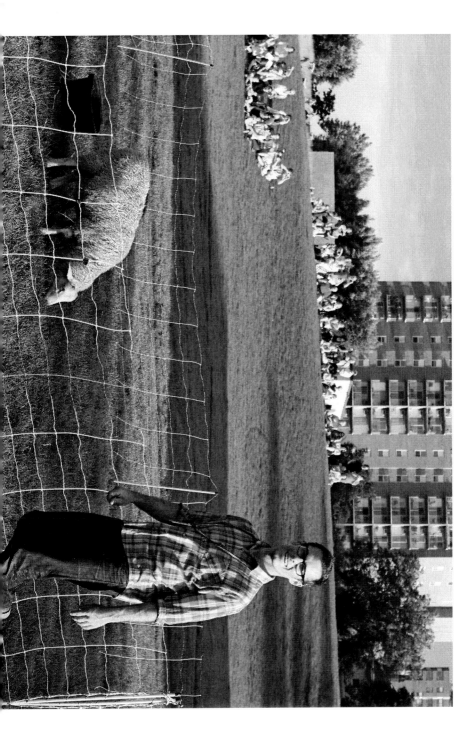

Grazing sheep perform the first section of Chris Kallmyer's *the American lawn and ways to cut it,* 2011

most fruitful and exciting parts of an experimental practice. Open Field is a complex enough public container that it allows for things to fizzle without people necessarily feeling embarrassed.

Often with projects in museums, there are a lot of clear signifiers—whether architectural or economic or introduced with signage—that tell you what the important things are and what the unimportant things are. My experience of doing projects with the Walker—not just for Open Field, but in general—is a feeling of benevolent neglect in terms of the curatorial ambitions of the museum. So, as an artist, it is a much easier way to work; it allows you to feel more like it's just a space or that it's *your* space, not one defined exclusively by the museum's directive.

When thinking about how cultural institutions function in society, I often think in terms of metaphors of permeable membranes. After working here, I think about Open Field like an air lock: there's the outside world, which isn't necessarily an art context, and there's inside the museum, which is clearly an art context. Open Field is this transitional space that the visitor passes through to go into the museum, so projects can propose different ways of looking at things using a very informal approach, which has a lot more flexible potential.

SS: Some of the criticism or confusion about Open Field concerns the idea of the space as an alternative to the gallery experience. Some people have questioned whether its activities provide a "real" museum experience. Does the field have the appropriate air of criticality that a museum should have?

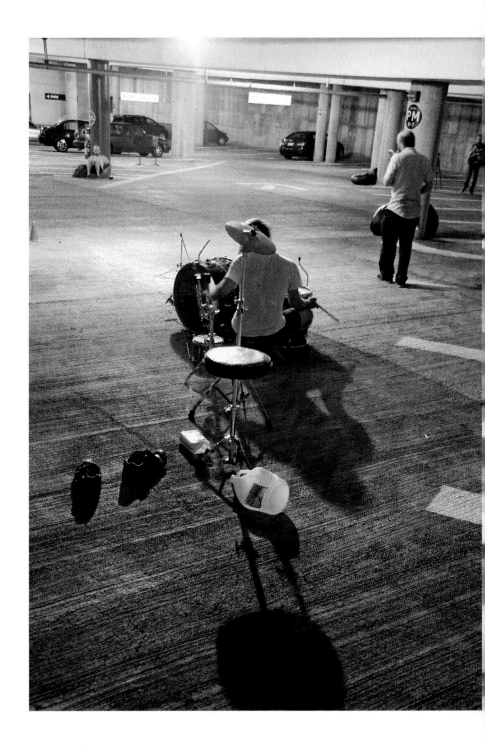

Jon Davis and Adam Patterson perform in the Walker's adjacent ramp as part of Chris Kallmyer's *Music for Parking Garages*, 2011

Emily Lacy performs on the plaza as part of her daily Cowboys and Angels tour, 2011

Girls playing with Sara Roberts' hand-held sound recorders as part of
Summer Jubilee, 2011

Jason Torchinsky demonstrates how to break out of a locked car trunk during the Car Theft for Kids workshop, 2011

MA: The answer really depends on your philosophy of the purpose of the museum, and that's a complicated question. There is a core traditional function that art museums do very well, which is to protect, preserve, and historicize objects, and to provide a focusing lens for the viewer to access those objects. The museum space is no more intrinsically critical than a telescope is; it's just a way of focusing. What you choose to focus on, and how you choose to articulate the relationships between things is where the curatorial criticality emerges in the institution. And that's not intrinsic to the fact the museum exists; it's dependent on how the particular curatorial process works.

What is interesting about Open Field is that it does something I believe is important for the museum's function, which is to construct a more discursive kind of space. The limitations of the museum purely as a focusing lens are such that it declares a priori what is valuable to look at, so the audience is not part of a discursive space so much as in the position of an observer.

I think in a very broad sense what is important about art in our culture is that it is a space for thinking about and proposing ideas that are not functionalized. It makes a space where we can look at an idea without saying, "OK, but does it make money?" Or saying, "OK, but does it cure cancer?" Or, "OK, but does it save on gas mileage?" We can look at ideas as potentially just interesting in themselves. I would like museums to more explicitly invite the public to be part of that process.

SS: *Along those lines, Open Field is an experiment and there has been interest in adapting aspects of the project inside the museum. How important is it that the messy experimental space, whether it's an artist project or an area outside the museum, is physically and conceptually bounded and contextualized? Does it become too chaotic if the whole museum is somehow a perpetual experiment?*

MA: In Machine's past projects for museums, they can sometimes feel more like a direct critique of the function of the museum, because they suggest an alternative reality or another way of doing business in the space. When we did the one-day project at LACMA, even though it was not a sustainable way for a museum to operate, it allowed us to imagine the museum as a sort of carnivalesque performance space full of continual activity.

I'm currently trying to think about how to embrace projects that are exploratory and contingent, while at the same time maintaining the museum's traditional functions. How do you do both things without saying that one is better than the other or that one should replace the other? And how do you sustain the tension between the two? There's a real value in sustaining that tension, because it allows you to take what is often invisible about the particular mode of looking that museums facilitate and make it visible. It's not about one replacing the other so much as it is about emphasizing what is special about each.

It's kind of like ice cream and hot fudge. I don't want to have just a giant bowl of hot fudge; it's a little bit gross. And just ice cream is a bit boring. Having the contrast makes both things seem better.

Embracing the experimental within the museum is complicated for contemporary art museums because, traditionally, they present experiments that worked out really great. This is quite different from presenting experiments at their institutions that are happening in real time and may be embarrassing for everybody involved. Museums are accustomed to presenting the thing that just happened, not the thing that is happening at that moment.

SS: It's really critical that you find a way to let the audience know that we're all in the middle of an experiment together, to be sure that we're being inclusive in this discursive space.

MA: I think you gain so much leverage by making that extremely simple-minded. And this is what I said to you before we started. We do a lot of things that suck, that are bad, that are, by all accounts, not good.

And you could say this to the audience, that a large percentage of the things we do will not be good—and it's not because you didn't get it, or you're dumb, or you don't understand contemporary art. But it gives you the opportunity to be there when something exciting happens. And actually, if you can move your embarrassment outside of yourself, it's really pleasurable to be at those events that kind of fizzle, right?

SS: Right. But there's a difference between doing that for two or twenty or thirty or forty people, or two people in an

environment that's free, as opposed to a 350-seat auditorium where you just paid $35 for the ticket.

MA: Yeah, that becomes more complicated. The question is, how does the contemporary art museum expand into being an experimental space as well? This is how I've started to think about Machine Project. The storefront, in particular, is like the R&D lab, where the things get tried out. And then when we go to other museums, sometimes we enter a scenario like with you guys at the Walker, where we could bring the R&D, actually, to a large institution and have it supported.

SS: It's interesting to think about the difference between attending an event that has been rehearsed versus one that is being figured out in real time. I suppose that's the difference between work that is experimental and work that is an actual experiment. The latter seems to have more potential for creating what I think of as a kind of liminal, "you-had-to-be-there" moment.

In previous conversations, you've talked about how people experience Machine experiments not only in real time, but also through the stories told about them after the fact. I think you referred to this as a kind of "folklore." This strikes me as an important part of how you work, the community that forms around Machine, and how your collective ideas circulate in the public imagination.

MA: There is something in particular about contingent and unreliable projects that connects to

how events and stories happen in our lives. In life, there's no guarantee what the outcome of an event or experience will be. There's always the possibility that something will turn out to be not very good. You don't necessarily know which party you go to that will give you an epic story you're going to talk about for ten years. I think that uncertainty generates a sense of possibility. This doesn't happen very much in museums because the quality has already been vetted. Work does not enter a museum until a bunch of people have decided it's really good. But in Open Field, things enter without anyone knowing if they'll be good or not and sometimes without anybody knowing they're entering at all. So as an audience member, your presence becomes more important—not that you make the work, but because you might be witnessing a tiny historical moment. If it is already guaranteed to be important beforehand, the public doesn't get to be an active part of that micro-history-making. So whether or not you attend the project, you can participate in perpetuating it as news or something significant.

IMPROV

Participants make music during Jason Torchinsky and Chris Kallmyer's
Apple II Beeptacular Spectacular workshop, 2011

ELECTRIC MELONS

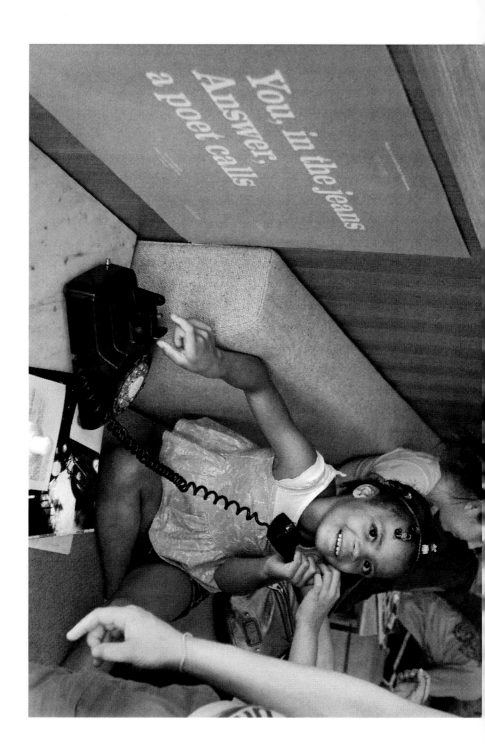

A pleasantly surprised visitor listens to the Poetry Phone, 2011

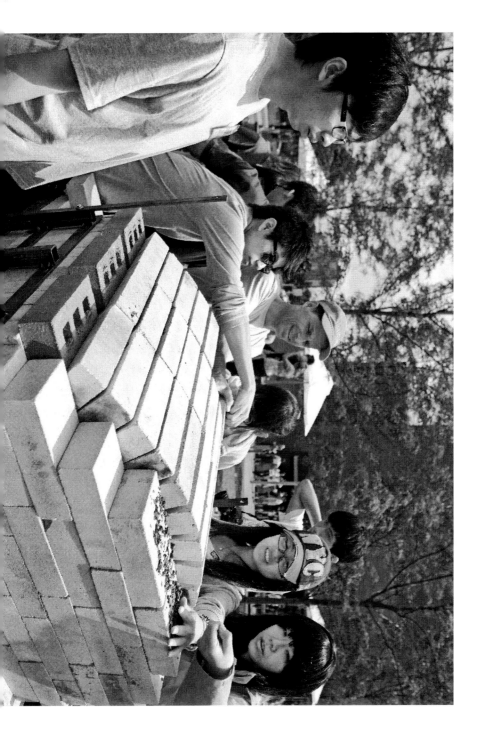

With help from visiting art students, Michael O'Malley builds a working pizza oven while discussing the work of artist Carl Andre (cooking and eating follow), 2011

A corral of reel mowers prepared for the public performance of *the American lawn and ways to cut it*, 2011

ECOSYSTEM

Living Classroom and Open Field

Interview with Marc Bamuthi Joseph

On August 18, 2011, the Walker hosted Living Classroom, a daylong gathering exploring the question, "What sustains life in your community?" Activities ranged from games of dominoes with artist/activist Rick Lowe, founder of Project Row Houses, and a community walkabout—a tour and conversation about animating public space led by local architect Marcy Schulte—to a program of table tennis matches, karaoke, and a slide show with photographer Wing Young Huie.

The Living Classroom was born out of conversations around a monthlong project with Marc Bamuthi Joseph, a spoken word/theater artist and educator dedicated to building and supporting

creative ecosystems. The residency was part of the Walker's ongoing relationship with the artist that also resulted in the co-commission and debut of his interdisciplinary performance work *red, black & GREEN: a blues* at the Walker in March 2012.

On an early site visit, Joseph and collaborator Brett Cook introduced his ongoing project Life Is Living—a series of eco and art festivals launched in urban parks nationwide that bring performance, intergenerational health, and environmental action to a number of artists and community organizations. Their visit left a residue of excitement and questions: Why would community-based artists and organizations want to produce an event at the Walker? Why would a project focusing on under-resourced communities be situated there?

The partners decided that the majority of the residency should take place off-site, and that projects about specific communities should be sited in partnership with local grassroots organizations. Workshops, professional development sessions, and a block party took place in several neighborhoods.

For the component at the museum, the framework of Life Is Living met the values of Open Field. The collaborating partners created a day that emphasized dialogue and mutual learning. Joseph talks about this process with Susannah Bielak.

Susannah Bielak: Your catalytic question for Living Classroom is, "What sustains life in your community?" Will you answer that question for yourself? What does sustainability mean to you?

Artist Rick Lowe hosts dominoes and conversation on healthy living and
community during the Living Classroom, 2011

RECIPE

Ping-Pong enthusiasts and artists Peter Haakon Thompson and Jenny Schmid host mini-tournaments on a Walker terrace as part of Ping and Sing with Wing: A Third Place Event, 2011

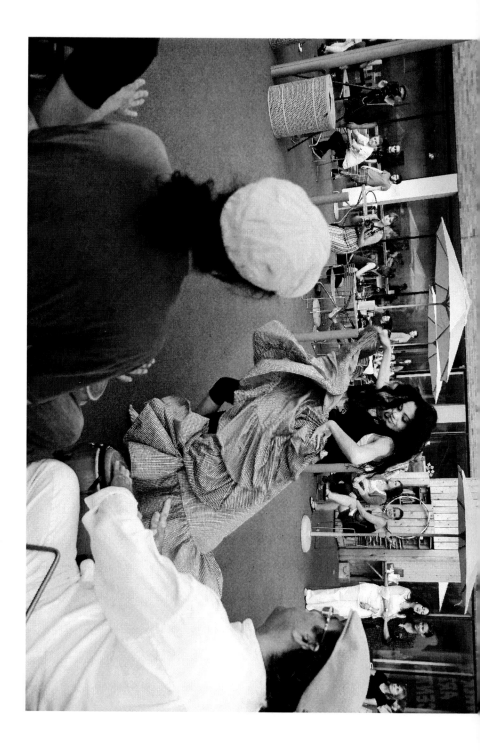

OSO and Luis Ortega bring bomba, traditional Puerto Rican rhythms, song, and dance, to the plaza, 2011

Marc Bamuthi Joseph: What sustains life in my community? Well, always the people, and the animal instinct to survive. "Sustain" is an interesting word because the fact is, my community, which for the purpose of this conversation I'll characterize as the African American community in Oakland, California, is actually leaving. That city is a place where death, education, and the level of incarceration are functioning at an unsustainable rate. So, you would think that what sustains life are the people who are doing their very best to turn those factors around—soulful, artistic, creative healers and creative problem-solvers sustain life in Oakland. The means of creative problem-solving keep changing. Some of the problem-solvers are farmers and food activists. Some are artists and athletes. Some are just good dads or good moms. But the creative healers sustain life in Oakland. They sustain life in my community.

SB: We're at a juncture where institutions are asking themselves about their relevance to the cities and communities in which they live. How do you see Open Field and the Living Classroom as related to the question of community sustainability and relevance?

MBJ: I think that the Living Classroom is populist and popular education at its best, but located at a specific site. What I love about the Living Classroom is that it invites a curated sample of organizations and artists to reveal and inquire about the best practices toward provoking thought around sustainability. So

much of our discourse is about saying, "I have an idea. I'm going to communicate this idea to you." This discourse instead is about creatively finding ways to ask, to provoke, and to invite people into the conversation. To me, that's a reflection of our Freirean pedagogy and it's also a reflection of good politics and city management, where policy development is predicated on this invitation into the conversation. That's what's great about Living Classroom.

SB: Something we've learned from Open Field is that a platform for the public's participation and collaboration requires structure and maintenance in order to flourish. As a self-described catalyst, what armatures do you build around participation, particularly for a project about sustainability?

MBJ: I am one of a class of what I call empathic intellectuals, which means that my discourse, my way of being in the world is based on energetic reciprocity. The word "armature" implies brick and mortar, steel and glass. But the primary structure that I build is energetic and emotional—finding a way not only in my own practice, but implicit and integrated inside my artistic fields of inquiry to generate safe space.

Whether we're talking about the formal or informal classroom or the performance space, growth happens inside a safe space. This might be indicated through iconography, through fields of play, or through certain kinds of music. But I really think it's the energy we ourselves carry that plays a role in this safe space. There are rigorous intellectuals who

are lousy teachers because they don't know how to orchestrate an environment for the interchange of information. Part of the whole strategy is to be intentional about safe space.

SB: It's interesting that you called out the word "armature." When I think of armatures in the context of this discussion, I think of soft architecture — the social structures, human work, and relationship-building at play in organizing. I see this integrally at play in projects such as Living Classroom and Life Is Living. What kinds of networks have you been part of, inquired into, and engaged with catalytically through this work?

MBJ: I think this goes back to the thesis of the work that we're doing — the ecosystem — which hopefully mirrors the grand design of nature, in that the more diverse we are, the greater chance we all have for survival. We are interdependent.

Part of what I strive to do inside of the performance space, and also inside of an organizing model, is to prioritize a sense of interdependence. Sometimes that looks like the Living Classroom, with all the activities and participants. Sometimes it looks like a poetry slam for youth, where there's a scaffolded development process for the young people, community participation on the audience level, and the integration of an institution such as the San Francisco Opera House or the Yerba Buena Center for the Arts, for example.

Again, I think it's my performance background and belief that as curators we're not just responsible

Building a collective collage around the question "What sustains life in your community?," 2011 Photo: Bethanie Hines

Spoken word artist Tish Jones and guests perform a Northside Renga Community Poem, 2011

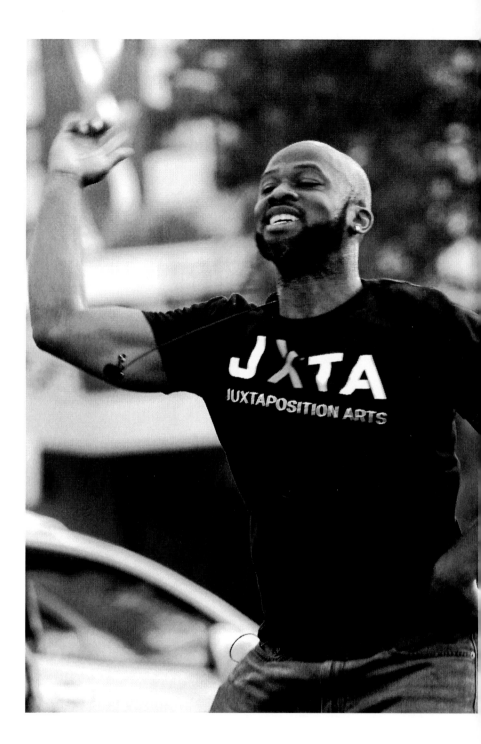

Marc Bamuthi Joseph performs an excerpt of his multimedia work *red, black & GREEN: a blues*, 2011

WALKABOUT

for locating objects in space, but we're also responsible for communal experience. And that's something I derived from my friend Ken Foster, who talks about communal experience being fundamental to the success of arts practice. Similarly, such experience defines the success of an organization. There are going to be some bumps in the road, emotional and logistical, but at the end of the day, if we have provided safe space for as many participants as possible, I think we're doing our job right.

SB: A phrase that we've been using in relationship to Open Field is that of a "cultural commons." While we don't explicitly use the term safe, *a driving principle of the project is to create a space where people want to be, and might really want to share. I'm wondering how you interpret the cultural commons, and what you might see as its value?*

MBJ: I love the phrase "cultural commons" because part of its value is both physical and nonphysical in terms of its occupancy of site. I think it's fantastic, and also speaks to democracy. The idea of common ground or middle ground is different from compromise, which implies that there have been concessions made, whereas commons, or the common ground, implies a space where everyone's ideas are welcome and preferred, if not prioritized. So I think that it's a great phrase, politically, socially, and artistically, and might be something that I adopt to talk about what we do, because that's really what it is.

SB: Life Is Living is a truly ambitious and multidimensional project that maintains a high degree of performance, including graffiti battles, youth spoken word, dance, and music. Here in the Twin Cities and at the Walker, the Living Classroom was far more about process and conversation than performance. Will Open Field and the process of the Living Classroom influence your artistic practice? Specifically, do you think the emphasis on the dialogical will influence you?

MBJ: Part of my arts manifestation is to reveal the process. There have been times at Life Is Living festivals when folks have asked me if I was going to perform. I would tell them that I am performing, that I don't have to be rhyming or doing choreography to be inside of my artistic manifestation. The piece that's going to come here to the Walker next year is evidence of that ideology—that we can reveal the arts process as the object of a performance, or the object to be viewed. All that being said, the Living Classroom is also performative. It's performance of culture; it's performance of process. It's also aesthetically beautiful.

The past few days, let alone my almost four-year relationship with the Walker, have introduced me to a certain vocabulary and to characters on the street that have placed me inside a context that will very much find its way into the finished product of *red, black & GREEN: a blues*. When we were in development with *the break/s* here about three years ago, there was something about the relationship between the education and community programs department,

the performing arts department, and the visual arts program that made me want to create a work to fit in the middle of all of them. That's what *red, black & GREEN* is, and what I think the Living Classroom is.

SB: When you came in April, you sparked our citizenry with the question, "What sustains life in our community?" It seems like the way you worked on this residency was to plant a powerful seed, leave it alone, and return to encounter the flowers growing out of the residents. Is this a typical practice?

MBJ: No, it's not a typical practice either for me or for the field. I would hope that it becomes more commonplace—this kind of active listening, quick turnaround, administrative dedication, and sacrifice. I think the current practice is for institutions to relate to an artist's ideas in the codified form of object, and to present a platform for those objects to live. But I love the way that the Walker has absorbed, at least for a time, an artist's process and integrated it into its own practices and processes.

Leah Nelson/Nubia and the OYIN dance collective perform as part of the
Living Classroom, 2011

JUG BAND

Commons Census: Surveying the Field

Shanai Matteson and Colin Kloecker

By the end of June 2010, Robert Dante, a profes-
sional bullwhipper, had become an Open Field leg-
end. Nearly all Walker staff described the day the
man with a whip came to teach kids how to do
something dangerous.

"Can we really do this? We can't do this! What if
someone gets hurt?" One staff member recalled her
initial fear after learning that an open call for public
participation had yielded a proposal for a class on
cracking whips. "I don't know if our liability insur-
ance even covers bullwhip accidents."

Another staff member seemed ambivalent about
the prospect: "Bullwhipping is awesome! But what
the hell does it have to do with art?"

These interviews were one component of Commons Census, our research project that sought to survey Open Field and explore what it means to create a cultural commons at an art museum. Over the course of the summer, we gleaned the thoughts of staff and participants on-site as well as those of artists, thinkers, and community leaders at locations around the city.

We set out to interview each and every Walker staff member about whether or not Open Field was changing the culture of the institution, and of the thirty conversations that resulted, many used the bullwhip lessons as a way to explore the meaning and impact of the field's public activities.

At first crack, bullwhipping has nothing do with art, but for one afternoon that activity proceeded alongside other unambiguous happenings on the field. Kids were rolling down the hill, groups of strangers were discussing the merits of individual colors around picnic tables, and some adults were simply enjoying a beer. What did any of this activity have to do with art? Was that even the right question to ask?

Many of the staff members we interviewed seemed less interested in what Open Field activities had to do with art than with what such undertakings said about public participation. It was, after all, an open field; the Walker was not curating or programming so much as facilitating public ideas and experiments, which were quickly found to be more varied, and in some ways more ordinary, than they'd expected. Among the yoga classes, Frisbee

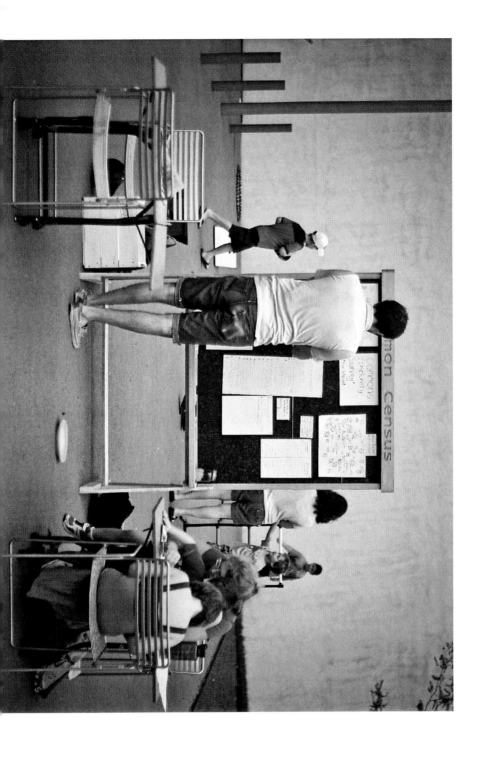

Colin Kloecker collates Commons Census surveys on Open Field Plaza, 2010 Photo: Zoe Prinds-Flash

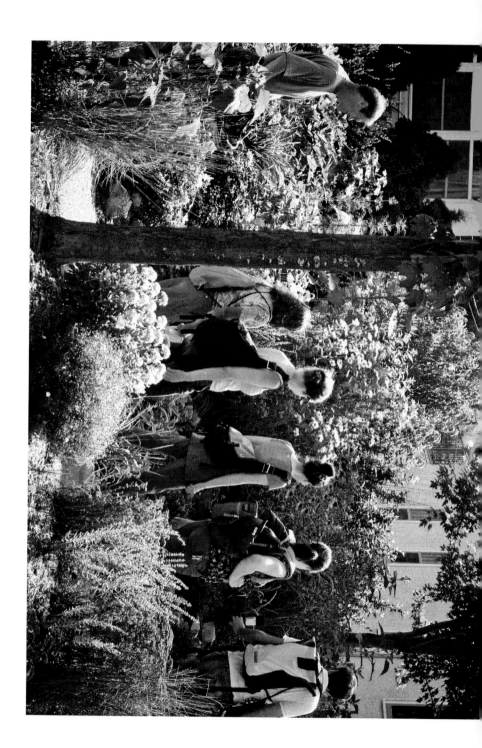

Common Census Field Trip exploring lawn as commons led by
John Archer, 2010 Photo: Zoe Prinds-Flash

SERENDIPITY

A Common Census Think Tank participant ponders a different kind of field at the Cedar Creek Ecosystem Science Preserve, 2010
Photo: Zoe Prinds-Flash

games, and book clubs, they all seemed to welcome the presence of the bullwhipper, if only because he exemplified their hopes and fears for the project.

One staff member described his perception of Open Field in this way, "It's great to see so many people here hanging out, so many families, but a lot of them are just hanging out. They're playing ladder ball. They're learning about bullwhipping. But they're not coming inside. They're not experiencing the art. How do we get them inside?"

Another staffer lamented, "Outside is fun. There's beer. You can learn to bullwhip! People are playing; they are creating. They are having conversations. How do we bring the outside in?"

One guard had this observation of the people who *were* going inside from Open Field to explore the galleries: "I've noticed that more people are getting close—are trying to touch the art. The kids are coming in and thinking they can run around. It's chaos, but what do you expect? They're running around outside, and the next minute they're supposed to be quiet and look at art?"

The narrative of inside/outside was not limited to talk of visitor behavior, but also to the perception of artists: "It's great that Open Field is offering space for artists to come and perform or share work. But I worry that people won't understand the difference between the inside art and the outside.... I wonder if people will come here to do something just to say they've exhibited at the Walker."

This tension was not surprising given the history and culture of art institutions, which have always

played their role in defining the territories of sanctioned and unsanctioned art. Open Field introduces a new, more ambiguous space, one that invites public participants to help create and define its parameters. The Walker commissioned large-scale residency projects from the artist collectives Futurefarmers and Red76, but both groups worked in partnership with other artists, students, and museum visitors to realize projects together. At the same time, artists from a variety of disciplines, communities, and professional backgrounds brought their own performances and projects to Open Field. Whether or not this concept made them uneasy, almost every staff member we interviewed seemed to embrace the experiment.

We wondered what visitors thought of the Walker's emphasis on play and public participation at Open Field, or about the notion that they were creating a cultural commons. To find out, we designed a simple survey based loosely on the US Census (the 2010 census was active at the time), and asked visitors to use it to engage one another in conversation on a broad array of themes. What was their reason for visiting the museum? What were their thoughts on which creative assets should or should not be held in common? What skills or knowledge did they have that they could share with others? Were they willing, at our suggestion, to explore the museum galleries with a complete stranger? We used a simple bulletin board and made hand-drawn visualizations on-site to reflect back what we were hearing.

What we learned was that in contrast to Walker staff, who seemed to labor over questions such as

the state of our cultural commons, participatory art, or the inside/outside nature of museums, Walker visitors, for the most part, just wanted to enjoy themselves. They came to the Walker to experience art inside and outside. To most, there was hardly a distinction, except that only one location was always free.

These desires to be entertained as well as enlightened have probably always been part of what drives public audiences to connect with cultural resources, and museums and other cultural institutions have always attempted to imbue this experience with elements of education or appreciation. So what was different about Open Field? Was it really an exercise in creating a cultural commons, where visitors, staff, and artists can share resources and co-create? Can an institution such as the Walker Art Center seed and than cede that kind of turf?

We needed to look outside the Walker to gain insight on these questions. The soul-searching of Walker staff and the offerings of public visitors could only open part of the field. As a final piece to our Commons Census project, we invited a group of artists and thinkers whose work engaged similar questions, themes, and practices as those explored at Open Field to join a roving think tank that would visit six other "open fields" around the Twin Cities in search of a deeper understanding of the Walker's project.

Over the course of the summer, this group visited an empty lot that artists and activists in the Frogtown neighborhood of St. Paul envision as the

site of a community farm; we toured a scientific research site where natural rather than cultural ecologies are studied, illuminating notions of diversity and resilience; we toured the Powderhorn neighborhood in Minneapolis with an expert on the history of the American lawn to see what we could glean about the Walker's big green backyard; we danced in public with artist Marcus Young, whose *Don't You Feel It Too?* project makes use of the open space of city streets to explore public performance and the transformative experience of embarrassment; we ate dinner in an alternative art space and met with artists who were exploring creative economies in a pop-up storefront.

These conversations, while far from Open Field, were perhaps the most generative, and ultimately the most enlightening. We learned that the questions posed by Open Field, while relatively new and exciting in the museum world, have deep precedents in other places. For Walker staff members who joined the series of field trips, it was a chance to steal some distance and perspective on the chaotic experiment unfolding just outside the museum walls. For participating artists and thinkers, it was an opportunity to get a sense of the field, broadly speaking. And for the public we encountered while visiting these sites, it was often an introduction to the Open Field project, and sometimes, to the Walker Art Center.

Most importantly, this part of Commons Census connected the museum to a larger network—one that we are all a part of—in meaningful ways. The inside/outside dichotomy seemed to lose relevance

when you stepped back and viewed the Walker's Open Field as just one of many cultural commons evolving in a city. Everywhere we went, the people we talked with spoke of a desire to create something meaningful together, something that was not based upon the exchange of money, but rather, of ideas, skills, or even simple conversation. Perhaps future iterations of Open Field will more fully embrace this patchwork landscape of fields, lawns, lots, streets, tables, and markets where cultural commons are in constant creation; and by listening to artists, audiences, and its own staff, perhaps the Walker can evolve while learning from Open Field and other ongoing experiments.

The commons is an elusive idea, and can't be summed up by any single definition or action. More than just a space where artists, the public, and museum staff could explore and co-create commons in fun, creative, and playful ways, Open Field provided a platform where participants were invited to share, and in many cases enact, their interpretation of the commons, even if that meant cracking a whip.

Cribbage enthusiasts on the field, 2011

A museum visitor takes a polygraph test as part of Mark Allen's Satisfaction (verified by polygraph) Guaranteed, 2011

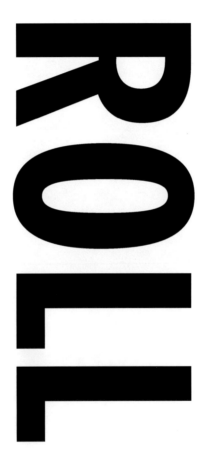

OPEN FIELD CHARETTE PARTICIPANTS

The design for Open Field was initiated through a team-based charette process involving some thirty architects, landscape architects, designers, artists, and other cultural thinkers from around the Twin Cities. The final plan involving the creation of a new plaza to anchor the site was designed by VJAA. Furniture and fixtures for Open Field, including the Tool Shed, were designed by David Dick and Tom Oliphant.

2010

Darsie Alexander, Walker Art Center
Ben Awes, CityDeskStudio
Olive Bieringa, BodyCartography Project
Maurice Blanks, Blu Dot
Andrew Blauvelt, Walker Art Center
Mike Brady, ROLU
Blaine Brownell, University of Minnesota
Bryan Carpenter, Alchemy Architects
Shane Coen, Coen + Partners
John Comazzi, University of Minnesota
John Cook, HGA Architects
Jim Dayton, James Dayton Design
Christian Dean, CityDeskStudio
Alex DeArmond, graphic designer
David Dick, Walker Art Center
Steve Dietz, Northern Lights.mn
Robin Dowden, Walker Art Center
Joe Favour, Oslund and Associates
Ryan French, Walker Art Center
Troy Gallas, Solutions Twin Cities
Bob Ganser, CityDeskStudio
Stephanie Grotto, Coen + Partners
Peter Haakon Thompson, artist
Vincent James, VJAA
Colin Kloecker, Solutions Twin Cities
Bryan Kramer, Coen + Partners
Matt Kreilich, Julie Snow Architects
Charlie Lazor, Lazor Office
Shanai Matteson, Bell Museum of
 Natural History
Tom Oliphant, TOMOCO
Matt Olson, ROLU
Tom Oslund, Oslund and Associates
Sarah Peters, Walker Art Center
Paul Schmelzer, *Minnesota Independent*

Sarah Schultz, Walker Art Center
Joan Soranno, HGA Architects
Julie Snow, Julie Snow Architects
Scott Stulen, mnartists.org
Piotr Szyhalski, artist
Marc Swackhamer, HouMinn Practice
Olga Viso, Walker Art Center
Geoffrey Warner, Alchemy Architects
Jennifer Yoos, VJAA
Cam Zebrun, Walker Art Center

2011

Christina Alderman, Walker Art Center
Scott Artley, Mixed Blood Theater
Jack Becker, Forecast Public Art
Juana Berrio, artist
Susannah Bielak, Walker Art Center
Olive Bieringa, BodyCartography Project
Peter Brabson, Minneapolis Arts
 Commission
Mike Brady, ROLU
Rachel Breen, artist
Betsy Carpenter, Walker Art Center
Marianne Combs, Minnesota Public Radio
Katie Condon, MacPhail Center for Music
Steve Dietz, Northern Lights.mn
Ashley Duffalo, Walker Art Center
Clea Felien, artist
Chris Fischbach, Coffee House Press
Troy Gallas, Solutions Twin Cities
Courtney Gerber, Walker Art Center
Sam Gould, artist
Tom Haakenson, Minneapolis College of
 Art and Design
Joey Heinen, Walker Art Center

Chris Jones, The Loft Literary Center
Bryan Kennedy, Science Museum of
Minnesota
Colin Kloecker, Works Progress
Megan Leafblad, Minneapolis College
of Art and Design
Mary Lee, Cantus
David Lefkowitz, artist
Vince Leo, Minneapolis College of Art
and Design
Shanai Matteson, Works Progress
Kristina Mooney, artist
Kristen Murray, designer
Sarah Peters, artist
Margaret Pezalla-Granlund, artist
Sarah Schultz, Walker Art Center
Ben Shardlow, Works Progress
Scott Stulen, mnartists.org
Piotr Szyhalski, artist
Miranda Trimmier, artist
Erik Ullanderson, artist
Mark Wheat, Minnesota Public Radio
Sarah Wolbert, architect
Marcus Young, artist
Wing Young Huie, artist

LARPers (Live Action Role Players) in the throes of a seventy-two-hour quest, 2011

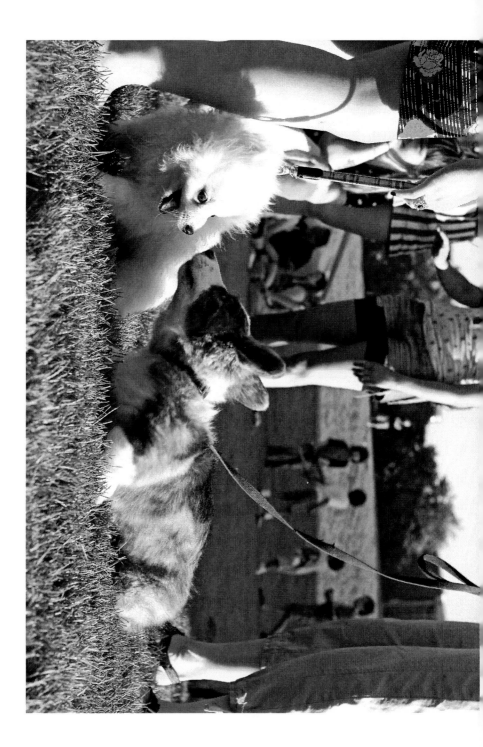

Dogs awaiting an outdoor opera (for dogs), 2011

OPEN FIELD ACTIVITIES ORGANIZED BY THE PUBLIC, 2010–2011

The following Open Field activities were organized and presented by individuals and community groups during the project's first two years.

2010

Perpich Center for Arts Education Final Literature Reading, June 10

Book Club Meeting, June 10

Crossword Club, June 4–September 3

Bullwhips in the Open Field, June 13 and 20

Language of Parenting, June 17 and July 2

The Play's the Thing, June 23 and 30, July 7, 14, and 21

Chromatic Summer, June 24–August 5

The Public Intellectual: Guru, Gadfly and Cultural Gunrunner, June 24, July 8 and 22

Talking Art with Walker Guides, June 25

Gorilla Yogis, June 26

Curatorial Cult Club/Kwestion Quration?, June 30

Contact Improvisation Jam, June 30, July 14, and September 2

Qi-Gong: 18 Harmonizing Movements, July 1 and 8

Independence Day Old-Time Appalachian String Band Music Gathering, July 4

Native American Government: First Peoples, First Commons, July 8

Suzuki Violin Play-in, July 10

Yoga, Food and Words, July 10

Meditative Yoga Movements with Affirmations, July 10, August 7 and 26

Hear/Share MN-SLA Highlights (Special Libraries Association's Annual Conference), July 15

Live Construction of Branch Pods by artist Sean Connaughty, July 15–17

Sketching with Inks from Nature, July 16

What do James Turrell and the Figure Have in Common...WE CAN DRAW THEM!, July 17

DiverCity, July 17

National Poetry Slam Preview Show, July 22

Design Activism Meeting with Students from the University of Minnesota, July 22

Swedish Song Session, July 22

The DV8D Septet Performs in the Turrell, July 23 and 24

Unseen/Seen: The Mapping of Joy and Pain, July 24

Creative Hula Hooping, July 25

Soul Power Group, July 29

Poetry Reading with Greg Hewett, July 29

Soul Power Group, July 29

One Woman. One Scooter. One Big Message, July 31

Be Zapped: See and Learn Flamenco dance, the percussive dance of southern Spain, July 31

Explorations in Play, July 31

Reed Trio, July 31

DesignBlocks: Create, Animate, August 4

Cocktails with Creatives — AIGA Minnesota, August 5

New Belgium Brewing Urban Assault Ride, August 8

Lotus Eater, August 8

Traces, August 10

Twin Cities Runoff, August 10

Renegade Ensemble, August 11

The Art of Hoarding, August 15

Looking for Creative Fertilizer — An Ideas Competition, August 15

Foodie Picnic: Potluck & Stories, August 15

Kavaima Finnish American Singers, August 15

Croquet!, August 18

GaGa-Israeli Dodge Ball, August 20

Human Chess, August 21

Fiber on the Field: Knit, Crochet, Spin, Weave, August 21

The Piper Down Experience, August 26

Meditative Yoga Movements, August 26

Speed Submissions! Pitch an idea to an editor at Coffee House Press, August 26

Moral Support, August 26

Poetry Pulpit, August 28

New South Bear Acoustic Set, August 29

Discussion: So Why Is this Art?, September 1

Blind, September 2

Trading Flowers for Love Stories, September 2

Iron Pour with artists from Franconia Sculpture Park, September 2

Final Contact Improvisation Jam, September 2

Evening in Seville with Anda Flamenco, September 2

Music by Eisner's Klezmorim, September 2

Jam in the Sky Pesher, September 2

T'ai Chi Chuan Studio, September 4

2011

Tai Chi Easy, June 8–August 31

The Play's the Thing, June 8–August 31

Bullwhips on the Open Field, June 11–August 27

Be Moved, June 11

Afoot and Light-Hearted: Poems of the Road, June 14

If You Ignore It, It Will Get Better, July 16–September 1

Tour Guide Happy Hour, June 16–
August 25

Newton Ave Book Club, June 16

KUBB Swedish Viking Chess, June 17 and
Friday, August 19

The Swatch Team: Yarn Bombers Unite,
June 23–September 1

Fresh from Philly…2nd Annual SLA Post-
Conference Sharing and Social, June 23

Hillside Sports and Games, June 24

The Experimental Meditation Center of
Los Angeles, June 25

Be a Super Hero, June 25

Tot Mama Yoga, June 28 and July 26

WARM: Discuss Art and Feminism, June
29, July 27, and August 31

Suzuki Violin Play-In Books 1–6, June 30
and August 25

From the Center, July 1, August 5, and
September 2

Story Making with Twin Cities Runoff,
July 2

Writers in the Sculpture Garden: Alabama
Loves Minnesota, July 2

Gorilla Yogis' Yoga Out of Captivity:
Roaming the Urban Jungle, July 9

Art Swap! Swap a Work of Your Creation
for Someone Else's, July 9 and August 27

Free Arts Minnesota Day in the Park, July 9

West African Dance & Drumming, July 9
and August 5

Spin with the Whorling Spinsters, July 10

The Ground Breaking Invent Event, July 14

Crafty Geek: Make Something (Awesome),
July 16

Flight Club, July 16

Come and Play, July 26

Infinity Circle, July 28

Hat Deco, July 31

Get Your Mallet On! Play Croquet, August 3

The Art of Social Skills, August 6

Optum-mum Nutrition, August 9 and 23

Art Warm Up, August 11 and 25

Color Coded: Order vs. Chaos, August 11

Summarize: A Letters vs. Numbers Music
Video, August 11

Speed Submissions, August 13

Cribbage in the Field: Open Games, Story
Swap, Art Board Show and Play, August 28

Music of the Sun, August 20

Flower POWR: A Flower-Making Workshop,
August 20

New Stories Exposed: A Game in Words,
August 25

Trailblazers, August 25

A-Pico-Lypse Now, August 27

Sketch-Y Conversations; Draw, Sketch, and
Interact with Architect-y Types, September 1

Seeds of Growth with Potato Prints — Ole!,
September 1

AIGA MN Cocktails with Creatives,
September 1

Marimba Music to Move to, September 2

Urban Assault Ride 2011, September 11

Life-size Morphology Event, October 8

FORECAST

OPEN FIELD ARTISTS-IN-RESIDENCE PROGRAMS, 2010–2011

2010

Works Progress: Commons Census, June–September, with Commons Community Surveys, Mission Statements, and Think Tank Field Trips (Street, Field, Lawn, Lot, Market, Table)

Red76: Surplus Seminar, July 20–August 8
 Red76 Surplus Seminar Kickoff Barbeque
 Anywhere/Anyplace Academy (A/AA)
 Pop-Up Book Academy with Bill Daniel on MicroCinemas
 Perfect Bound Surplus Books
 Film Screening: Who is Bozo Texino?, with Bill Daniel
 Pop-Up Book Academy with Gabriel Saloman on Magical Activism
 House Show as School House at Community Gardens with Robust Worlds, To Kill A Petty Bourgeoisie, Invisible Boy, Strong Bones, Daughters of the Sun, curated by Tom Loftus
 YouTube School for Social Politics with Courtney Dailey
 Pop-Up Book Academy with Dan S. Wang on Paul Wellstone and Rural Labor Organizing
 Stephen Duncombe: Utopia Is No Place
 Pop-Up Book Academy with Stephen Duncombe on Utopian Theory
 House Show as School House at Medusa with Synchrocyclotron, Thunderbolt Pagoda, Bottom Jobs with George Cartwright, curated by James Lindbloom

YouTube School for Social Politics with Emily Foreman
Pop-Up Book Academy with Unsettling Minnesota on the Decolonization Movement
Film Screening: Selections from the Walker's Ruben/Bentson Film and Video Study Collection, curated by Jeremy Rossen of Cinema Project
Pop-Up Book Academy, with Aaron Hughes on Veteran War Resistance
House Show as School House at 1419, with Gaybeast, Mother of Fire, No Babies, Orange Coax, and Brute Heart, curated by Dan Luedtke, with May Day Band and Parade organized by Jackie Beckey
Floating Academy

Futurefarmers: A People Without a Voice Cannot Be Heard (commissioned by the Walker Art Center and Northern Lights.mn), August 6–September 4
 Futurefarmers Welcome Barbeque
 Taking the City by Voice: Roger Hoel + Minnetonka Girls Chamber Choir
 How to Build a Voice Box I: Dunce Caps into Megaphones (Shouting into a Megaphone Until You Become Hoarse), at Free First Saturday
 The Voice in Sound and Vision with ethnomusicologist Allison Adrian
 Film Screening: Rick Prelinger's The Lives of Energy
 Film Screaming, Robin Schwartzman, Ben Desbois, and Justin Spooner
 Theorist Daily Talk: Rick Prelinger and Star Tribune Field Trip

How to Build a Voice Box II:
Unregulated Radio: The Promise of
the Democratization of Media with
Anthony Tran at mnartists.org Field
Day
24-Hour Newspaper
Auctions Speak Louder Than Words

2011

Machine Project
Summer Jubilee, July 19–29
The Experimental Meditation Center of
Los Angeles—Come Meditate with
Us!, Adam Overton
Invisible Performances Pamphlets,
Adam Overton
Poetry Phone, Joshua Beckman
Cowboys and Angels, Emily Lacy
Car Theft for Kids, Jason Torchinsky
Music for Parking Garages, Chris
Kallmyer
Musicians: Casey Anderson, Chris
Kallmyer, Jonathan Zorn and Rachel
Thompson, Jon Davis and Adam
Patterson, Paul Rudoi, and Members
of Cantus
Tragedy on the Sea Nymph: An Operetta
in Three Acts Starring an All-Dog
Cast: Elizabeth Cline
Music: Lewis Pesacov
Conductor: Kela Wanyama
Vocalists: Juliana Snapper, Chad
Freeburg, Lisa Drew, Sara Kantor, and
Andrea Leap
Musicians: Cedar String Quartet
Opera Listens to You, Juliana Snapper
Vocalists: DV8D Septet
*Chris may or may not play trumpet
at some time and some place
possibly. . .*, Chris Kallmyer
Satisfaction (verified by polygraph)
Guaranteed, Mark Allen
Apple II Beeptacular Spectacular, Chris
Kallmyer and Jason Torchinsky
The Fol Chen Verbal Algorithm
Composer-Free Song Generator,
Samuel Bing and Sinosa Loa of Fol
Chen (Asthmatic Kitty)
Meet the Earbies or Games for Ears,
Sara Roberts

Composition for Photoelectric Array and
Ambient Light, Kamau Patton
Electric Melon Workshop, Mark Allen
Echo Park Film Center: Filmmobile
Workshops and Screening
World of Pickling, Chris and Rhett
Roberts, Nick Schneider, Andy
Sturdevant, Robin Schwartzman, and
Barb Schaller
the American lawn and ways to cut it,
Chris Kallmyer
Krystal Krunch's Never Been to Me Tour,
Asher Hartman and Haruko Tanaka

Marc Bamuthi Joseph, August 15–18
The Living Classroom, August 18
Collective Collage, Desdamona
Drawing Club, Carolyn Anderson, Julie
Buffalohead, and Jim Denomie
Ping and Sing with Wing: A Third Place
Event, Wing Young Huie, John Kim,
Peter Haakon Thompson, Jenny
Schmid, and David Peterson
Dominos, Rick Lowe, copresented by the
Walker Art Center and Kulture Klub
Collaborative
Instructions for Peace, Marlina Gonzalez
Voices on Sustainability, Tish Jones,
Line Break Media
Juxtaposition Arts S.T.E.M. Expo,
Juxtaposition's S.T.E.M. students
Community Walk About, Marcy Schulte,
in partnership with Citizens for a
Loring Park Community and Friends
of Loring Park
Story Circle, Leah Cooper and Anton
Jones
Messaging Your Community: Twin Cities
in Frame, Line Break Media
Dance X/Masego, Leah Nelson/Nubia,
and OYIN: A Dance Collective
Community Renga, Tish Jones
Sneak Peek: *red, black & GREEN: a
blues*, Marc Bamuthi Joseph
OSO Presents Bomba, OSO and
Luis Ortega
Citizen Journalists, Jonathan Blaseg,
Natalie Clifford, Allison Herrera,
Dr. Zenzele Isoke Andrea Jenkins,
Lolla Mohammed Nur, Julia Nekessa
Opoti, Amanda Spencer, Kinh T. Vu
Living Classroom After Party at
Juxtaposition Arts

Additional participating artists for the Living Classroom: Brett Cook-Dizney, Bethanie Hines, and Eli Jacobs-Fantauzzi

Additional partnership organizations for the Living Classroom: Conway+Schulte Architects, Cultural Wellness Center, Imagining America, Intermedia Arts, and the Minneapolis Parks Foundation

Coffee House Press hosted Speed Submission where anyone could pitch
a book to an editor in six minutes, 2010

SWORDPLAY

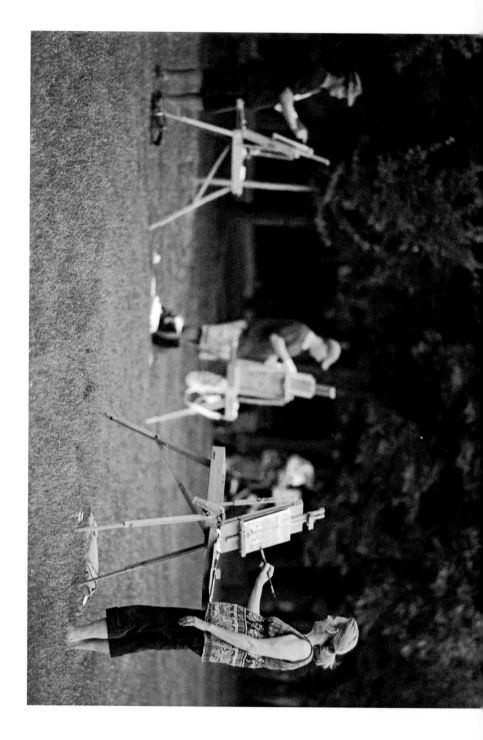

Plein Air Garden Party as part of mnartists.org Field Day at Open
Field, 2010

PICNIC

WALKER ART CENTER OPEN FIELD PROGRAMS, 2010–2011

The following Open Field programs were organized and presented by the Walker.

2010

Opening the Field: A Celebration and Conversation, June 3, with panelists Michael Edson, Sumanth Gopinath, John Ippolito, Laura Musacchio, and Caroline Woolard; moderated by Colin Kloecker and Shanai Matteson of Works Progress

Drawing Club, Thursdays, June 3–September 2, with Roua Abul-Hasan, Katie Aguado, Hannah Albert, Nina Allen, Dave Branch, Rachel Breen, Alan Brewer, Sean Connaughty, Theresa Crushshon, Susan Davies, Pete Driessen, Callie Edwards, Robyn Freedman, Cris Godoy, Shawna Lee, Jason Lentz, Joe Lipscomb, Xong Lor, Ginny Maki, Jane Mason, Charles Matson, Barry McMahon, Ruben Nusz, Jill Otto, Jehra Patrick, Judith Pratt, Jamie Sandhurst, Maria Santiago, Emily Sheehan, Charles Standley, Laura Stack, Lora Stoyanova, Joshua Stulen, Scott Stulen, Brian Swerine, Bruce Tapola, Marria Thompson, Sara Udvig, Pamela Valfer, Krista Kelley Walsh, Lyz Wendland, and Michelle Westmark

Acoustic Campfire, select Thursdays June–September, with performances by Eisner's Klezmorim, Matt Schufman, Cantus, and Echo Collective

Free First Saturday, June 5, with activities by Ax-man Surplus Stores, Creative Kidstuff, Kindermusik, Zenon Dance Company, designers and educators from D.E.M.O. and the University of Minnesota College of Design, Leonardo's Basement; and performance by Roma di Luna

Free Geek Twin Cities, June 10

Making Connections, June 24, Adam Jarvi of D.E.M.O.

Free First Saturday, July 3, with activities by Susan Armington; Drawing Club guests Ute Bertog, Lenora Drowns, David Hedding, Eryka Jackson, Christopher Park, Carl Perkins, Samantha Sather, Brooke Tiegan, and Page Whitmore; and performances by tectonic industries, Wild Goose Chase Cloggers, and Pert' Near Sandstone

Open Exposure, July 11, with performances by Tapes 'N Tapes, Eyedea & Abilities, Total Babe, Just Wulf, BubbleTeeth, and Wolf Mountain

Target Arts and Wonder Free Family Day, July 16, with activities by Ben Garthus and performance by Lucy Michelle and the Velvet Lapelles

Free First Saturday, August 7, with activities by Futurefarmers and Three Rivers Park District and performances by Copper Street Brass Quintet and Switzerlind

mnartists.org Field Day, August 19, with activities by David Lefkowitz and the Manual Image Assemblers Local 47, Tom Maakestad, Ben Garthus, and Community Supported Art artists; and performances by D.J. Mal, Carnage, Rockstar Storytellers, Holly Munoz, Roe Family Singers, and Velvet Davenport

Lewis Hyde: In Defense of the Cultural Commons, September 2

Harvest Picnic, September 3

Free First Saturday, September 4, with
activities by Futurefarmers with Glen and
Dale Fladeboe; and performance by Savage
Aural Hotbed

2011

Open Phenology, Fridays, May 13–
September 2, Abigail Woods Anderson

Free First Saturday: Play the Field!, June 4,
with activities by Leonardo's Basement and
Ben Garthus

Nightshift, June 4–5 (presented by
mnartists.org, Rain Taxi Review of Books,
and the Walker Art Center as part of
Northern Spark, produced by Northern
Lights.mn), with performances by Grant
Cutler, Caly McMorrow, Ryan Olcott
(FoodTeam), Scott Puhl, Chris Strouth
(Paris-1919), Vortex Navigation Company,
Jim Woodring, Megan Mayer, and Marcus
Young

Drawing Club, Thursdays, June 9–
September 1

Plein Air Painting Demos with Wet Paint,
select Thursdays June–September, with
Josh Cunningham, Mary Esch, and Fred
Anderson

Acoustic Campfire, select Thursdays
June–September, with performances by
the Hummingbirds, Potluck and the Hot
Dishes, the White Whales, Adrian Freeman,
Cruel Haiku, Mila/Orkestar Bez Ime, Adriana
Lisette, Malamanya, and Andy Sturdevant

Cookies, Corona, and Conversation around
a Manual on How to Activate Space,
June 21, Amanda Lovelee, Colin Harris

The Early Stage Advisory Group of the
Alzheimer's Association Meet-up, June 24

First Supper, June 30, Betsy and
Carl DiSalvo

Free First Saturday: Indie-pendence Day,
July 2, with activities by Emanuel Mauleon,
DJ Nex and D.J. Mal, DelRae "D-Ray"
Coleman, and Kenna-Camara Cottman; and
performance by Gustafer Yellowgold

Open Field Arrow Workshops & Exchange,
July 7 and August 4, Mike Haeg

Brown Bag Conversation on City Building,
July 15, Ashley Duffalo and Mary De Laittre

The Bank of Our Common Wealth, July 21,
Rachel Breen

Read Me the Garden, Sing Me the Garden,
July 22, Courtney Gerber with Shahzore
Shah of Cantus

Karl Raschke and Baron von Raschke:
Fame, Family, and Mayhem, August 4, with
director Phil Harder

Free First Saturday: LARPers, August 6,
with activities by Erik Ullanderson

Reading Room, August 12–17,
Chris Fischbach

EcoSomatics Classroom, August 25,
Olive Bieringa and John Schade

Harvest Party, September 1

Free First Saturday: Square Dance-a-thon,
September 3, with activities by Optum
Health and Amanda Lovelee

Workshop: Yo Mama! Institute,
September 10, with Amoke Kubat
and ROLU

mnartists.org Field Trip, September 24,
presented in partnership with Silverwood
Park, with activities by Faux Poco, Tom
Moffatt, Carl Judson, and Amanda Lovelee;
commissioned artwork by Aaron Dysart,
Alonso Sierralta, Richard Bonk, Rebecca
Krinke, Mary Johnson, Sean Connaughty,
Tamsie Ringler, and Alexa Horochowski;
and performances by Music of the Sun,
Malamanya, Brian Laidlaw and the Family
Trade, Matt Latterell, and the White Whales

LAWN MOWER

ORIGAMI

CONTRIBUTOR BIOGRAPHIES

Mark Allen is the founder and executive director of the Los Angeles–based collective Machine Project. He is currently an associate professor of art at Pomona College and a board member at the Andy Warhol Foundation.

Susannah Bielak is an artist and associate director of public and interpretive programs at the Walker Art Center. She was the project manager of Living Classroom and curates ongoing Open Field programming.

Courtney Dailey is a maker of objects, texts, events, and myriad collaborative and collective situations. She currently resides in San Francisco.

Steve Dietz is a serial platform creator. He is the founder, president, and artistic director of Northern Lights.mn, which produces the Twin Cities nuit blanche art festival Northern Spark, among other projects. He is the former curator of new media at the Walker Art Center, and the curator of Futurefarmers' residency for Open Field 2010.

Ashley Duffalo is the public and community programs manager at the Walker Art Center. She was the project manager for Futurefarmers and Machine Project residencies and curates ongoing Open Field programming.

Stephen Duncombe is an academic and an activist. He is an associate professor at the Gallatin School of New York University and the author of the book *Dream: Re-Imagining Progressive Politics in an Age of Fantasy* (2007).

Amy Franceschini is an artist and educator based in San Francisco whose multimedia work encourages platforms of exchange and production. She founded the artist collective and design studio Futurefarmers in 1995 and cofounded Free Soil in 2004.

Futurefarmers, founded in 1995, is a group of artists and designers collaboratively creating work to challenge and critique current social, political, and economic systems. The collective's studio supports art projects, an artist-in-residency program, and research interests. Futurefarmers was co-commissioned by the Walker and Northern Lights.mn to conduct a residency on Open Field in August 2010.

Dylan Gauthier is a visual artist, curator, and media educator based in Brooklyn. He is a cofounder of Mare Liberum, an experimental boat-building, print-making, and publishing collective.

Sam Gould is the cofounder of Red76. His interests concern politics, sociality, culture, and education. He teaches in the Text and Image Arts department at the School of the Museum of Fine Arts, Boston.

Lewis Hyde is a poet, essayist, translator, and cultural critic with a particular interest in the public life of the imagination. A MacArthur Fellow, Hyde is the author of numerous publications, including *The Gift: Creativity and the Artist in the Modern World* (1983) and *Common as Air: Revolution, Art, and Ownership* (2010).

Jon Ippolito is an artist, curator, and advocate for network art and culture. He is associate professor of new media and co-director of the Still Water lab at the University of Maine.

Marc Bamuthi Joseph is the director of performing arts at the Yerba Buena Center for the Arts in San Francisco and an internationally presented performer. His distinctions include a National Poetry Slam championship and a United States Artists Rockefeller Fellowship. In August 2011, he and collaborating partners presented a week-long residency at Open Field.

Colin Kloecker is an artist and designer working at the intersection of public engagement and civic design. With a background in architecture, he has created numerous public art projects as co-director of the design studio Works Progress.

Machine Project is a loose confederacy of artist/performer collaborators based in Los Angeles' Echo Park neighborhood. Founded by Mark Allen, the group's work investigates art, science, music, literature, food, and more. In July 2011, Machine Project and the Walker presented Summer Jubilee, a two-week residency consisting of more than eighteen unique projects at Open Field.

Shanai Matteson, an artist, writer, and cultural producer, has led myriad collaborative, cross-disciplinary projects. As co-director of the studio Works Progress, she draws on her interest in science and systems to produce public art and design programs at the intersection of disciplines.

Sarah Peters co-created Open Field during her tenure as the associate director of public and interpretive programs at the Walker Art Center. She is currently an independent writer, educator, and arts programmer.

Rick Prelinger is an archivist, writer, and filmmaker keenly interested in the commons. He is the founder of the Prelinger Archives, a collection of 60,000 advertising, educational, industrial, and amateur films, which was acquired by the Library of Congress in 2002.

Red76 is a nationwide network of artists and activists that since 2000 has conducted projects in physical space, in print, and online that focus on the ways knowledge is produced and the forms it takes. Their 2010 Open Field residency was organized by Courtney Dailey, Dylan Gauthier, Sam Gould, Gabriel Mindel Saloman, and Mike Wolf.

Gabriel Mindel Saloman is a Vancouver-based artist, writer, and musician. His artistic, curatorial, and musical projects include Diadem, the STAG, Collective Jyrk, the Lower Mainland Painting Co., and Yellow Swans.

Sarah Schultz is the director of education and curator of public practice at the Walker Art Center. In addition to co-creating Open Field, she has led the Walker's efforts to engage diverse communities with contemporary artists and art forms for more than a decade.

Scott Stulen is a co-creator of Open Field and founder of the Drawing Club. A practicing artist, he is the project manager of mnartists.org, an online resource for more than 18,000 Minnesota artists.

Michael Swaine is an artist and educator dedicated to working in the community through socially engaged art practice. He is a senior lecturer at the California College of the Arts and an analog designer with Futurefarmers.

Mike Wolf is "a collaborative free radical contaminating primarily the tissues of the Midwestern United States through experiential research, writing in the first person, drawing, taking walks, and talking about it all." The Illinois-based artist is a member of the collective Red76.

Works Progress is an artist-led public art and design studio based in Minneapolis, Minnesota. The group's collaborative projects are known for providing new platforms for public engagement across creative and cultural boundaries.

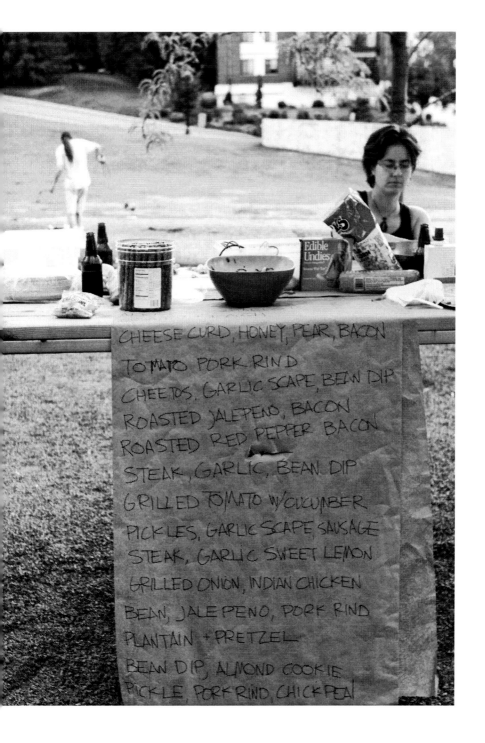

CHEESE CURD, HONEY, PEAR, BACON
TOMATO PORK RIND
CHEETOS, GARLIC SCAPE, BEAN DIP
ROASTED JALEPENO, BACON
ROASTED RED PEPPER BACON
STEAK, GARLIC, BEAN DIP
GRILLED TOMATO w/CUCUMBER
PICKLES, GARLIC SCAPE SAUSAGE
STEAK, GARLIC SWEET LEMON
GRILLED ONION, INDIAN CHICKEN
BEAN, JALEPENO, PORK RIND
PLANTAIN + PRETZEL
BEAN DIP, ALMOND COOKIE
PICKLE, PORK RIND, CHICKPEA

Using ingredients purchased from downtown Minneapolis' storefronts, skyways, and farmer's market, a team of food experts makes and shares dozens of pizzas on the field, 2011

Machine Project's official Walker ID badges, 2011

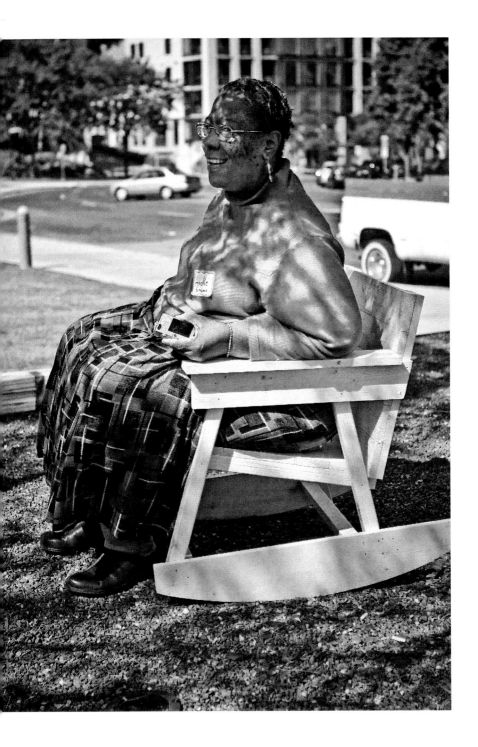

Amoke Kubat, artist and founder of the Mothering Mothers Institute, pauses in her Sick & Tired of Being Sick & Tired Chair, created in collaboration with ROLU design studio, 2011

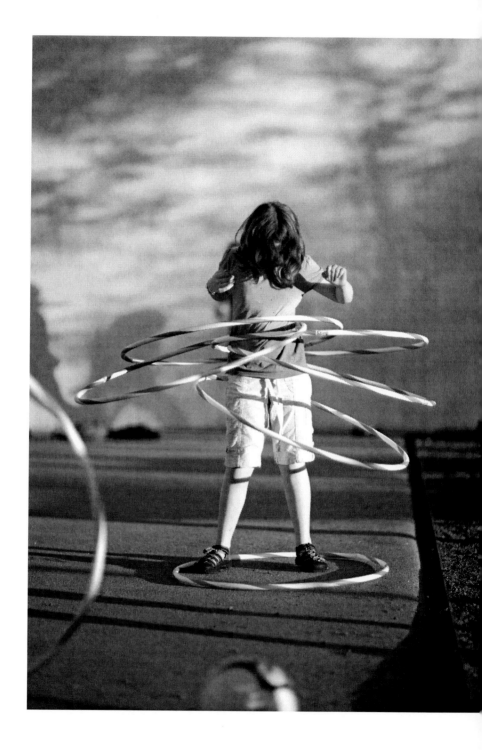

A very popular pastime on Open Field, 2011

PRETEND

Bullwhip expert Robert Dante teaches his craft, 2010

Open Field: Conversations on the Commons is a Walker Postscript, the Walker Art Center's print-on-demand publishing imprint, which presents short and focused texts to delve more deeply, or broadly, into the rich concepts that animate the institution's diverse artistic programs.

Major support for Open Field is generously provided by the Margaret and Angus Wurtele Family Foundation.

Open Field
Walker Art Center, Minneapolis
June 3–September 5, 2010
June 4–September 4, 2011
June 2–September 1, 2012

Library of Congress Cataloging-in-Publication Data

Walker Art Center, compiler, sponsoring body.
Open Field : conversations on the commons / edited by Sarah Schultz and Sarah Peters ; contributions by Susannah Bielak and [nineteen others]. --
First Edition.
pages cm
ISBN 978-1-935963-00-4
1. Open Field (Program : Walker Art Center) 2. Art museums and community--Minnesota--Minneapolis. I. Schultz, Sarah, editor of compilation. II. Title.
N583.A25 2012
707.1'0776579--dc23
2012015789

First Edition ©2012 Walker Art Center

Available through D.A.P./Distributed Art Publishers, 155 Sixth Avenue, New York, NY 10013
www.artbook.com

ISBN 9781935963004

Design Director
Emmet Byrne

Designer
Alex DeArmond

Editors
Pamela Johnson, Kathleen McLean

Senior Imaging Specialist
Greg Beckel

Design Studio Coordinator
Dylan Cole

Printed and bound in the United States by Lulu.com